# ILLUSTRATION
# WITH MARKERS

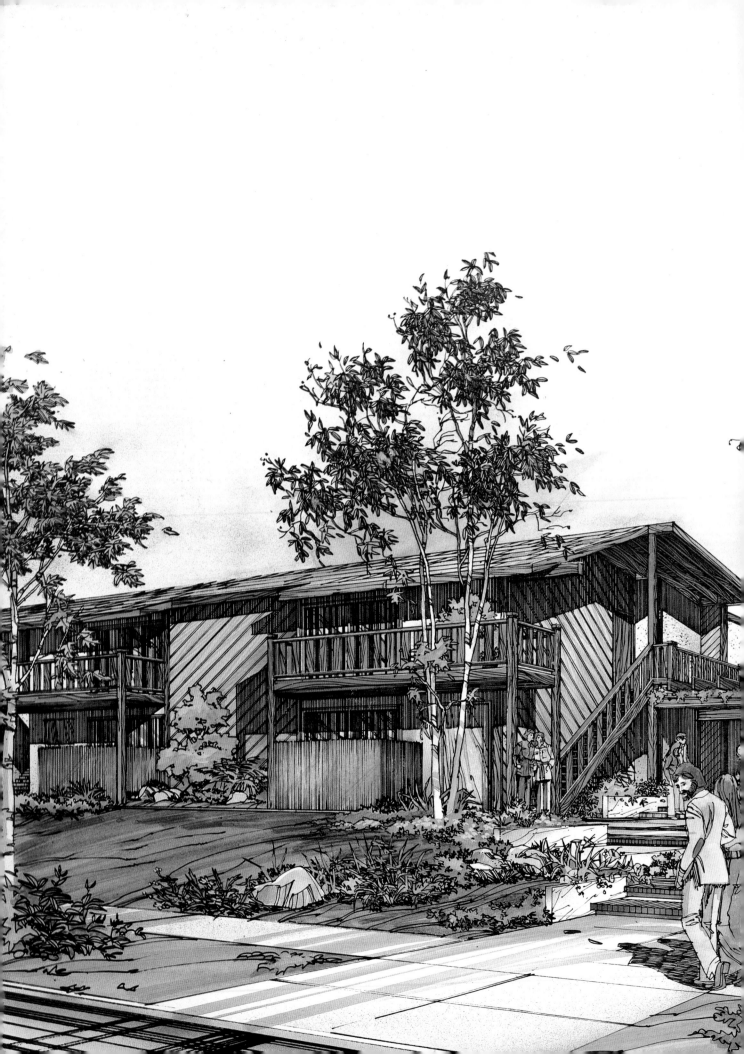

# ILLUSTRATION WITH MARKERS

## JOHN A. GLEASON

WHITNEY LIBRARY OF DESIGN
AN IMPRINT OF WATSON-GUPTILL PUBLICATIONS
NEW YORK

First published in 1991 by Whitney Library of Design,
an imprint of Watson-Guptill Publications,
a division of BPI Communications, Inc.,
1515 Broadway, New York, N. Y. 10036

**Library of Congress Cataloging–in–Publication Data**
Gleason, John A.
    Illustration with markers: time–saving techniques for design
    professionals/John A. Gleason.
       p.  cm.
    Includes index.
    ISBN 0–8230–2536–5
    1. Dry marker drawing—Technique. 2. Felt marker drawing—
    Technique.   I. Title.
NC878.G57 1991                        90–49767
741.6—dc20                             CIP

Manufactured in Singapore

First Printing, 1991

1 2 3 4 5 6 7 8 9 10 / 96 95 94 93 92 91

This book is dedicated to my wife of 26 years, Linda.
The life of a designer is not a steady one, nor is it always prosperous. She stuck with
me for better or worse, and without her support I would not have written this book.

I would also like to thank my editor, Marisa Bulzone, for helping my words
make sense, and getting more out of me than I thought I knew.

Thanks also to Cornelia Guest, who believed me when I said I could write,
without any evidence other than my word. She also supported me when
it seemed like I would never finish the first chapter.

# CONTENTS

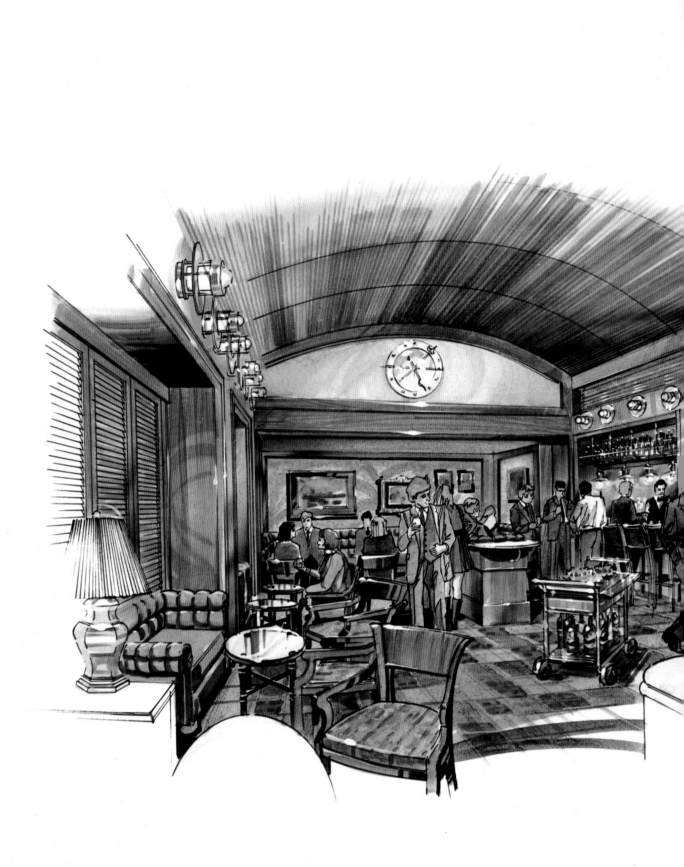

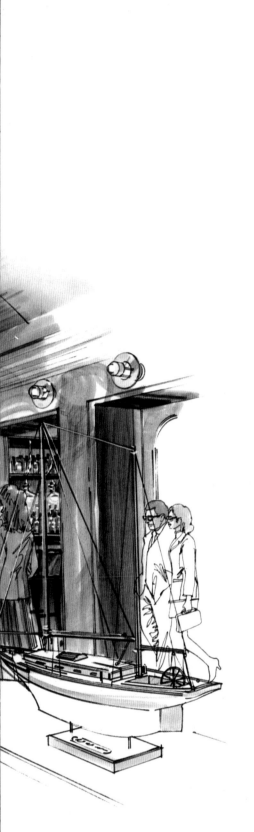

# INTRODUCTION

An exciting illustration has a life of its own, and will draw admiring comments from viewers for its own merits of style and technique, apart from the design information it is intended to convey. This aspect of illustration can intimidate a good designer, as well as a novice, because professionals recognize the importance clients place on presentation, even at the concept stage of a design project.

In a sketch, the designer works out his or her initial design concepts, first solidifying them in his or her own mind—using the sketch as a design tool—and then using the sketch to convey to others what has already been visualized in the design process.

In recent years, the chosen media for these initial concept studies has become the felt-tip marker, with its quick application, vibrant colors, and reliable palette. The immediacy of the marker is what makes it preferable for this type of sketching, although the impermanence of the medium must be acknowledged. When you use a marker, you are applying a dye to the paper, a dye that is, by its very nature, only temporary. Marker sketching has become the "word-processor" of design, the universal medium of quick, easy, colorful design studies. As a new medium, there are few codified rules regarding proper sketch technique, and many designers simply teach themselves.

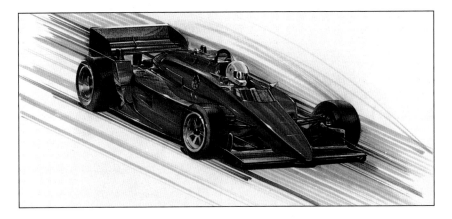

Sketches that sparkle, like this CART racer, may be placed on a wall with fifteen or twenty alternatives in a large automobile design studio, each competing for the viewers' attention.

As products are designed, hundreds of sketches can be generated by the design team over time, each sketch showing the possibilities visualized by the individual designer, and viewed within the studio, or later presented to the client. It is not possible to know in advance which sketch will represent the best or final effort. It may be that two or three are combined to make one final design, utilizing the best features of a few of the previous efforts. This is why designers use marker sketches; it is vitally important to have a simple, quick means of visually illustrating a product or design idea on paper.

The professionals who use the felt-tip marker recognize its unique qualities, and unlike as with other, more permanent media, you will usually find it is the practicing illustrator or designer that has a set of markers, not the hobbyist or the advanced amateur.

This book has been designed to eliminate the time-consuming trial and error used in the past by many professionals in learning to work with markers. Whatever your design responsibilities, you will benefit from the simple approach to marker sketching outlined in this book and the time-saving tips that have been learned the hard way by practicing professionals.

Your desire to improve your marker techniques is probably tied to a desire to grow in your ability as a designer, as well as an illustrator. Markers are chosen as a tool for sketching and creating finished commercial art, not as a fine art medium. This basic fact will help you to adjust your marker technique without overworking or spending too much time on refinements. You will be working on a copy of your line art, not your original. Get into the habit of discarding a sketch if you have overworked an area, and always try to keep the casual, "quick sketch" look that gives a marker sketch its style and impact.

The illustrations shown throughout the book were created by the author, and will be used to demonstrate how you can achieve your final goal—whether it is to create a preliminary drawing or a final, finished piece of art.

As a visual communicator, you are judged first by what you present on paper—your sketches. Yet these are very limited; the viewer cannot move around, smell, or touch what you are trying to show. The first impression is what sells a sketch. You may have spent hours working on a sketch, but the client will decide in seconds whether he or she likes what is being presented.

Marker sketches can be used to depict a designer's vision for a wide range and variety of subjects, from complex farm machinery to a simple amenities package. However, no matter what the subject, you will find that many of the same techniques are employed—when working with markers, one technique builds upon another.

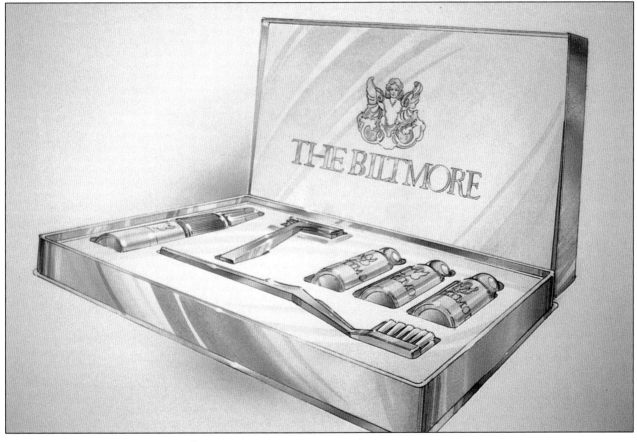

Markers are ideal for design studies because they are bright, vibrant, and alive. This is the look you are striving for, and it can easily be achieved by using the right tools and techniques. However, the very attributes that make the marker inks vibrant and alive also doom them as temporary, transient representations of the concepts being communicated. Remember, marker studies are the communicators of an idea, not an art form.

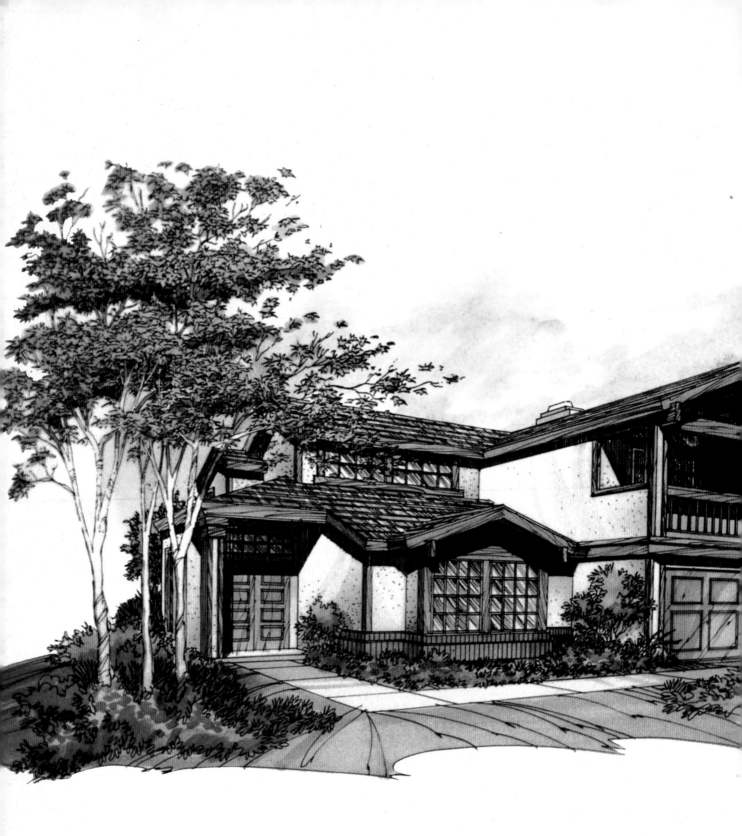

# WORKING WITH MARKERS

When you first begin to work with markers, you may be confused by the vast array of materials available. There are several major marker lines and a large assortment of papers, pencils, and other supplies necessary for your finished art.

To learn the techniques shown in this book, you will be asked to follow the steps outlined, and you will need to use Berol Prismacolor markers. The illustrations used in this book were done on electrostatic copies of pencil or ink line drawings, and then colored using Berol markers.

Once you have mastered the skills outlined in this book, you can select any manufacturer's marker, but remember that only the Berol marker line, with its alcohol-based ink, will color copies without destroying the line. Always use the best tools and materials. Their cost is very small in relation to the value of the project or concept they convey. If you vary your tools, your results will not be reliable or consistent. Too much is at stake for you to cut corners on materials—a job, a design fee, or a career. It's not worth the risk to scrimp. Professional illustrators are very conservative about the tools of their trade—they only use the best, and they continue to use the same tools that have proved reliable in the past, and will remain reliable in the future.

You will find that standardizing your markers will help you to gain confidence in your sketching ability. You will see consistent results, and as your confidence grows you will feel free to experiment.

The felt-tip marker should fit comfortably in your hand; its color should come out in a smooth, consistent manner, and be reliable. Berol markers have these qualities, and the double tip, one at each end, is an added plus. The alcohol base also makes for a nontoxic work environment; you may find you breathe easier when you use them.

When selecting your paper, you will find Clearprint brand 1000hp vellum to be a reliable choice. Vellum is an ideal paper for marker sketching, as you can blend color and work on the back of the paper as well as the front. At this weight, it can also be run through an office photocopier.

Teaching the techniques of marker sketching is very rewarding, but it is sometimes difficult to get the student to use the quick, easy strokes that evoke the work of a practiced professional. This is because the student is concerned that a mistake will destroy hours of labor, and necessitate redoing the whole sketch. Modern technology is going to help you in your progress as a marker sketcher. By working with copies run through an office copier, you can use the same line drawing over and over until you begin to see the results of your efforts. An office copier that can take 11 x 17" (28 x 44 cm) paper will prove an excellent beginning. Later, as the need arises, you may wish to find a local blueprinter with a large Xerox or Shacoh machine able to make copies up to 36 inches (92 centimeters) wide and to any length desired. A word of warning: If you use a blueprinter's large copier, be sure you get a *nonerasable* copy. Erasable copies cannot be colored.

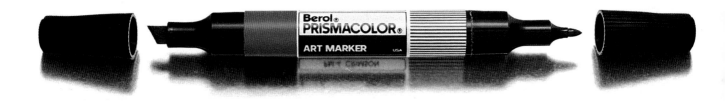

The Berol marker, with its double tip and alcohol-based ink, is the choice of many professionals.

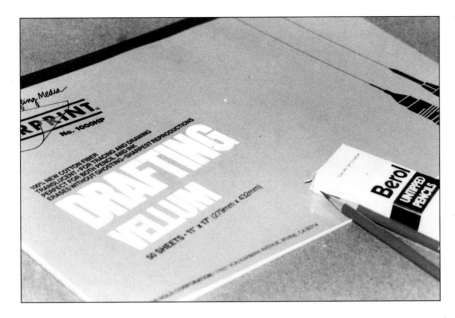

Before you begin your first exercises, purchase an 11 x 17" (28 x 44 cm) pad of Clearprint 1000hp vellum (fifty sheets in a pad), select a line drawing you already have (or draw a new one), and photocopy it onto several sheets of vellum, as shown below. Make enough copies so you will feel free to discard the first few if you are not satisfied with your practice strokes. It is most important at this stage that you develop the loose, easy stroke that is so necessary to the creation of a good sketch.

Making multiple copies of your line drawings will also be your biggest timesaving technique. You are free to reuse repetitive art (decals that run through a copier), or work with more than one color scheme. You also can enlarge, reduce, and reverse your drawing as many times as you need or want.

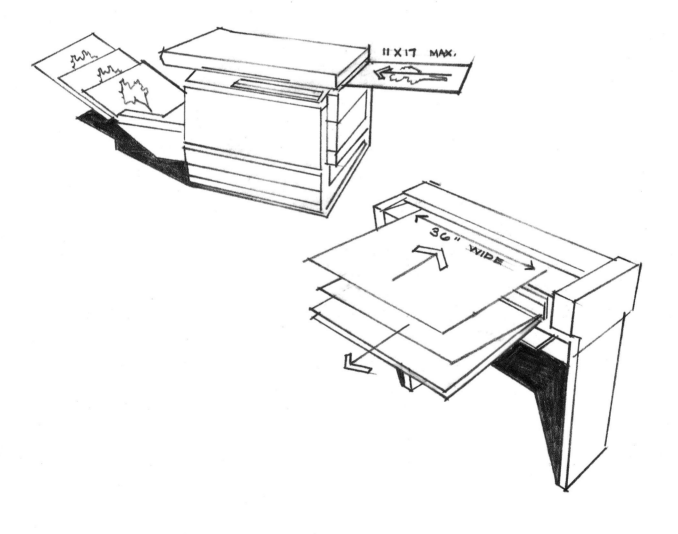

1   This is a package of "sticky-back" decals that will run through an office copier. These are easy to use, and great time savers. Load the decal blank in the copier, copy your art onto it, and you are ready to apply it to your original.

2-3 Transfer your decals to wherever you wish them to appear in your final sketch (they can be applied to the back if you use flimsy tracing paper), and finish your drawing around them.

4   Notice this sketch of three trees—I drew it once, but because I have photocopied the original sketch, I can reuse the trees over and over. Once they are applied to a blank sheet of paper, my drawing is 25 percent done, and I have saved the time it would have taken me to draw them onto the vellum.

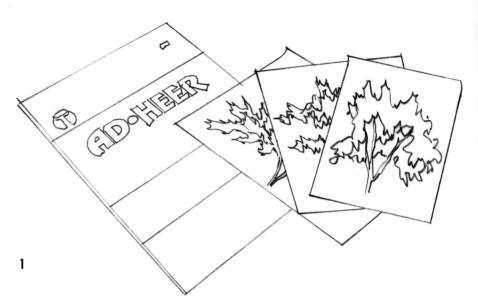

1

4

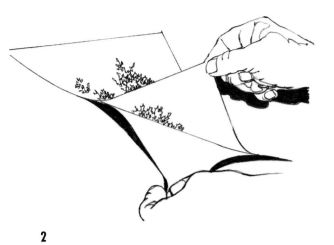

**2**

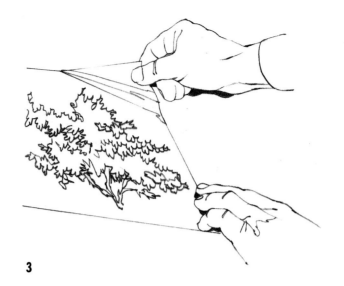

**3**

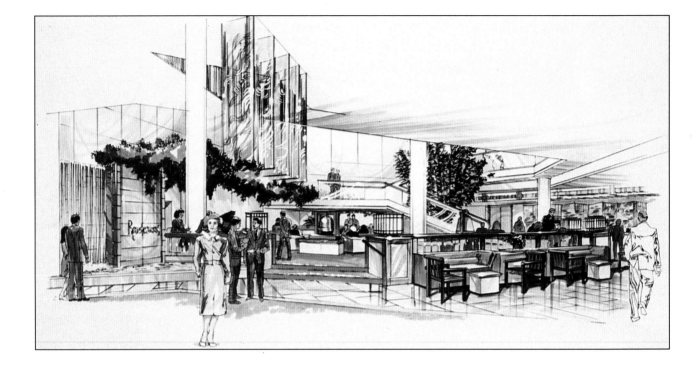

Rendering with watercolor paint requires a great deal of time and effort before you can begin to produce professional results. You must develop a "feel" for the paint, and the ability to paint large areas of color must be mastered before acceptable results are seen.

Unlike most presentation media, the felt-tip marker lends itself to finishing a small area at a time, thus giving the beginner an opportunity to do quality work by applying what he or she has learned to a sketch one area at a time.

This ability to finish small areas is caused by the way marker color is applied: directly on the paper, with a short "wet" time. Watercolor paint can remain wet for twenty minutes, enabling the artist to connect large areas before they dry. Marker color may remain wet for ten *seconds* (on vellum), allowing only small areas to be connected. This also means the area can be "worked" very quickly, with no time lost waiting for paint to dry.

Examine the rendering shown. At first, it may seem to be quite complex, but it was actually done with a very limited number of techniques. Here you will see that the organization of the sketch is as important as the execution. Working from light to dark, each succeeding application of a darker color covers anything lighter, and you can "trim" any previous area of light color. This is because you are tinting the paper, not totally covering it. For example, if you have a beige wall next to one of dark wood, color the beige area first, letting the color run into the next section. You can then color the darker wood, trimming the beige overlap by coloring right over it, because the darker color will totally cover the lighter beige. Carefully choose the sequence of color application; you will not only save time, but will have a better sketch as well.

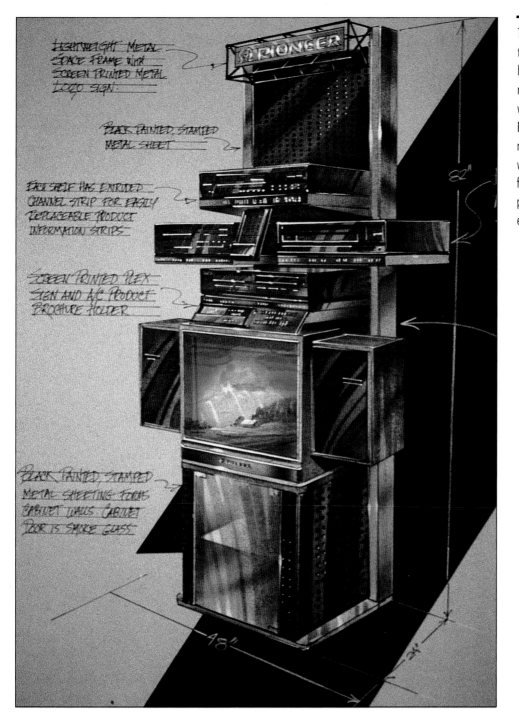

The key to a fine marker sketching technique is to give the illusion you have a variety of widths to your marker and a wide tonal range, when in fact you have neither. Examine the sketch shown and notice how rarely you see one width of color that would reflect the felt-tip width. This is the result of practice and a conscious effort to enrich the sketch.

### EXERCISE ONE: THE BASIC MARKER STROKE

1  On a clean sheet of vellum, practice making side-to-side strokes that connect. Observe that there is an actual period of time when the marker color on the paper is wet. This is why vellum is preferred—it absorbs ink less quickly than other surfaces and while the color is still wet, you can connect strokes, blend, and rub with tissue more easily.

When practicing your strokes, work with actual shapes while putting down color. Notice that a sketch does not have to extend from edge to edge, so if you have a pleasing stroke, you can lift up and create a vignette of color around your drawing.

2  As you apply color to a line drawing, you will instinctively try to stay within the lines. This tends to inhibit the free and easy quality of your strokes, and is not as necessary as you might think. Practice turning your paper so your natural arm swing gives an unbroken sweep.

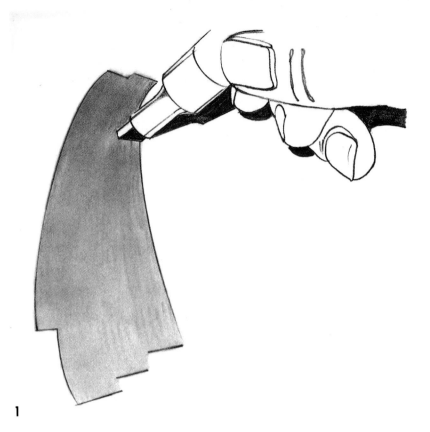

**1**

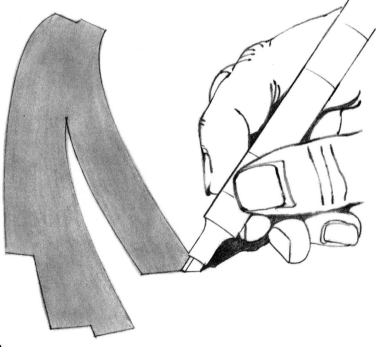

**2**

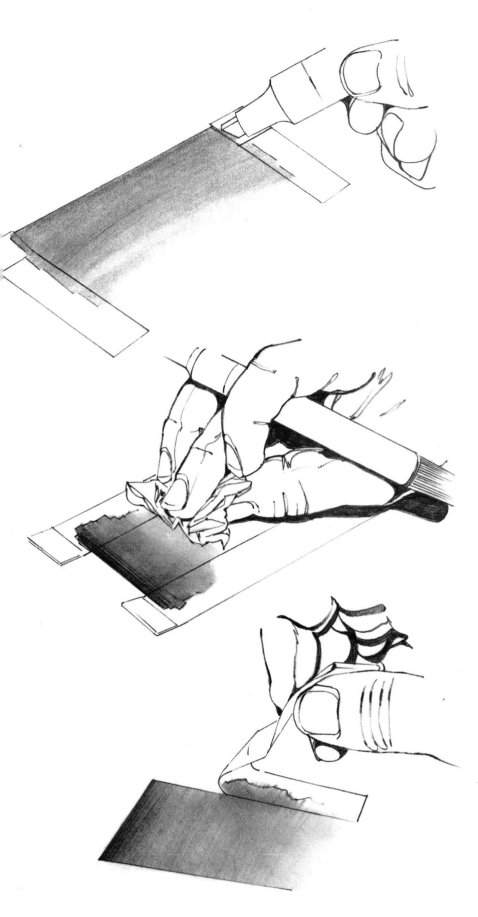

## EXERCISE TWO: MANIPULATING COLOR

As you can see, when working with the side-to-side sweep of your hand, it is only necessary to hold the drawing line at the top of your stoke. You can mask either side, or trim with the adjoining color to eliminate areas of color that have gone "out of bounds" at the sides. The best tape to use for masking is frosted 3M Magic Mending tape. Turn one end over so you can easily pick it up from the vellum, and practice on scrap until you feel comfortable that you will not tear the paper.

Tape each side of a broad area, and connect your strokes to create a wash of color. Try different stroke widths, learn the extent to which you can comfortably connect your strokes, and plan your next sketch accordingly.

Review the color examples shown so far in the book, but this time look for clues about how wide a stroke is possible. Each of the examples shown was planned with the capabilities of the artist in mind. Look at the red racing car shown in the introduction—the background strokes look like they were done for the car, but in actuality the size of the car itself was selected to be no larger than what could easily be covered by one side-to-side stroke.

Tape either side of a two-inch-wide area, apply marker to about three inches in length, and then quickly rub the wet end with tissue to give an even transition from dark to light. Try this with different colors and see if you can mix colors to extend the range from the darkest to paper white.

These basic exercises give you an introduction to the possibilities of manipulating the color after it is on the paper. *This is the secret of advanced marker illustration.* It will be the basis of all of your work with markers in the future.

### EXERCISE THREE: ESTABLISHING COLOR SEQUENCE

Make your practice sessions fun. You'll find you can fool the eye and improve the quality of your work as you go along. As you master the basics, apply them as much as you can in your sketching. Timing is important, and it can only be learned with practice.

Observe the coloring sequence of this simple interior. You will see the same principles that you learned in the previous exercises have been applied. The marker color has been stroked on in variable widths, and then rubbed with tissue to change the tonal range and achieve the effect desired.

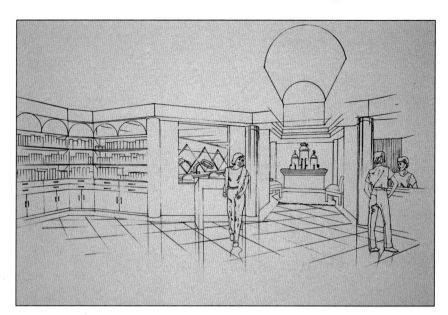

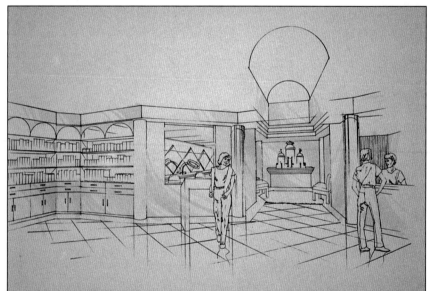

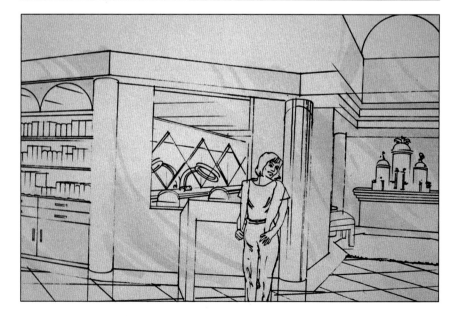

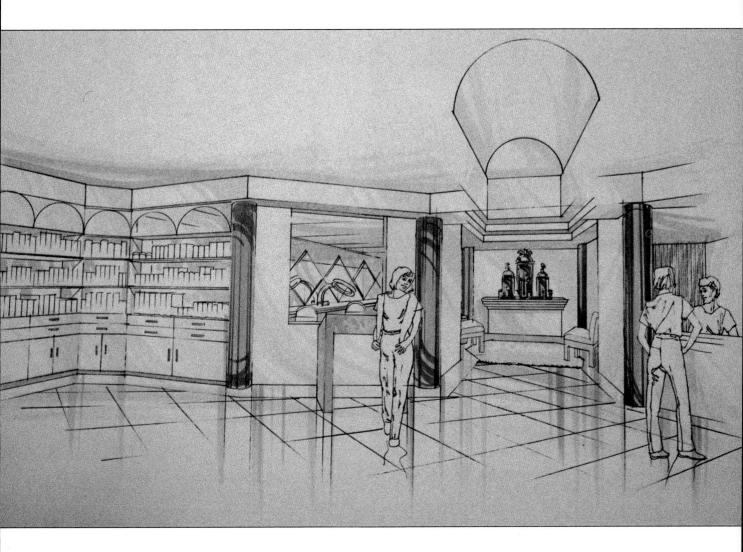

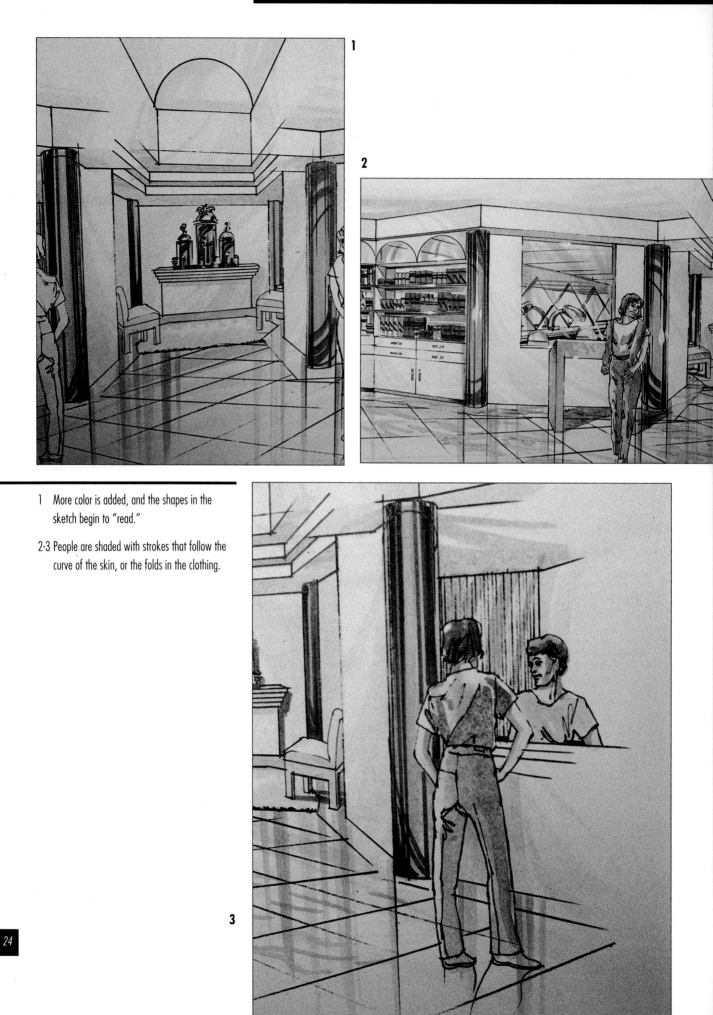

1 More color is added, and the shapes in the sketch begin to "read."

2-3 People are shaded with strokes that follow the curve of the skin, or the folds in the clothing.

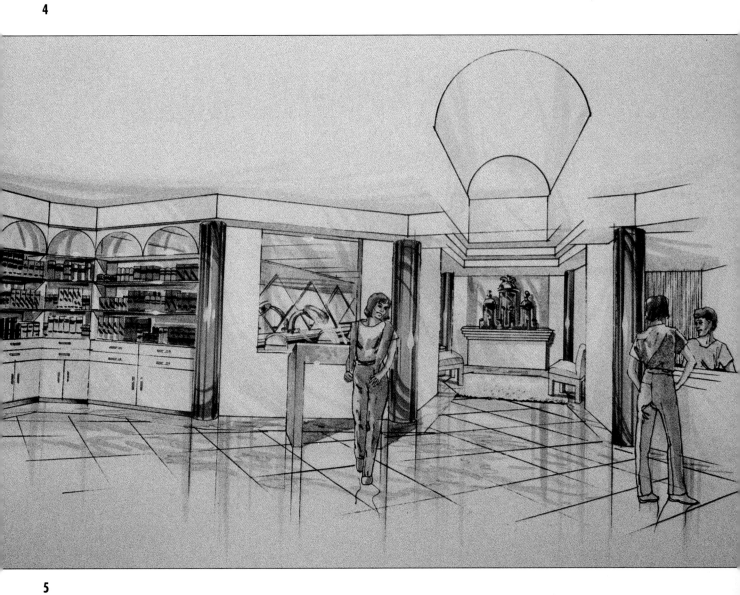

4 The product is given form, the mirror is emphasized, and highlights are added.

5 The final result is merely the assembly of simple shapes, laid on step by step, as you have done in completing the previous exercises.

This simple sequence of overlapping color application is the basic foundation for all the techniques developed in this book. Take the time now to master this method; you will find each succeeding chapter will build on these basics, enabling you to quickly progress in your marker-sketching ability.

4

5

1 Work habits are important, as is a knowledge of your tools. Develop the habit of recapping your marker before you set it down; never lay it down open. The "click" of the cap tells you when it is properly closed. Markers are cheap; your time is not. Do not try to save a dry marker; instead, prevent your marker from drying out in the first place.

2 As you acquire markers, consider getting the 120-color stand. Organize it with the numbers in order, and you will find you can reach out and pick up the exact color you want quickly.

3 Make a color chart, copy it onto vellum, and have the exact color each marker makes on your paper right in front of you.

1

2

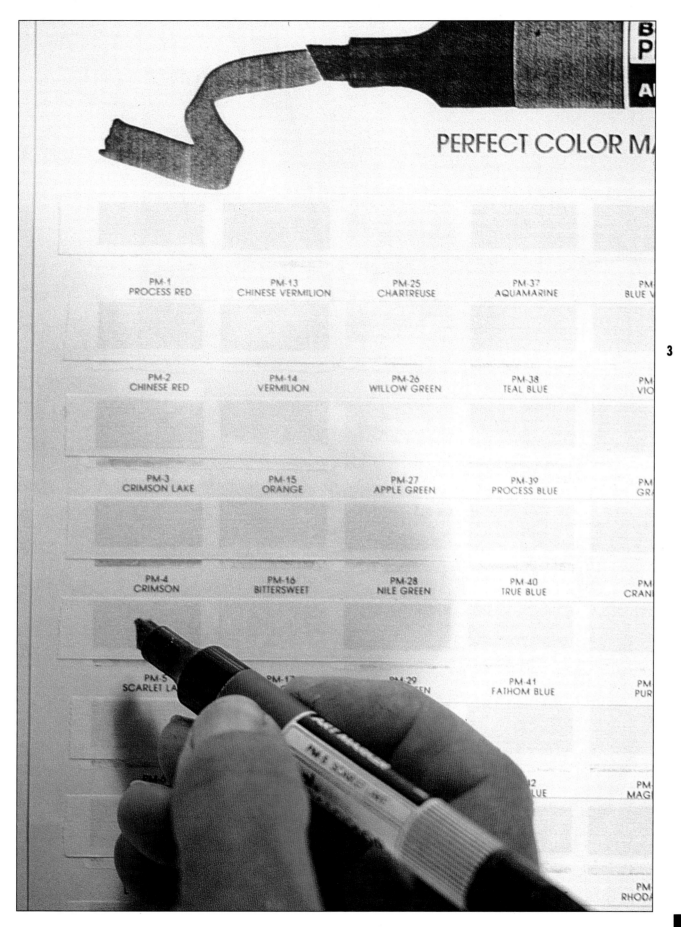

PERFECT COLOR MA

| PM-1 PROCESS RED | PM-13 CHINESE VERMILION | PM-25 CHARTREUSE | PM-37 AQUAMARINE | PM BLUE V |
| PM-2 CHINESE RED | PM-14 VERMILION | PM-26 WILLOW GREEN | PM-38 TEAL BLUE | PM VIO |
| PM-3 CRIMSON LAKE | PM-15 ORANGE | PM-27 APPLE GREEN | PM-39 PROCESS BLUE | PM GR |
| PM-4 CRIMSON | PM-16 BITTERSWEET | PM-28 NILE GREEN | PM-40 TRUE BLUE | PM CRAN |
| PM-5 SCARLET LA | PM-17 | PM-29 EN | PM-41 FATHOM BLUE | PM PUR |
| | | | 42 LUE | PM MAG |
| | | | | PM RHODA |

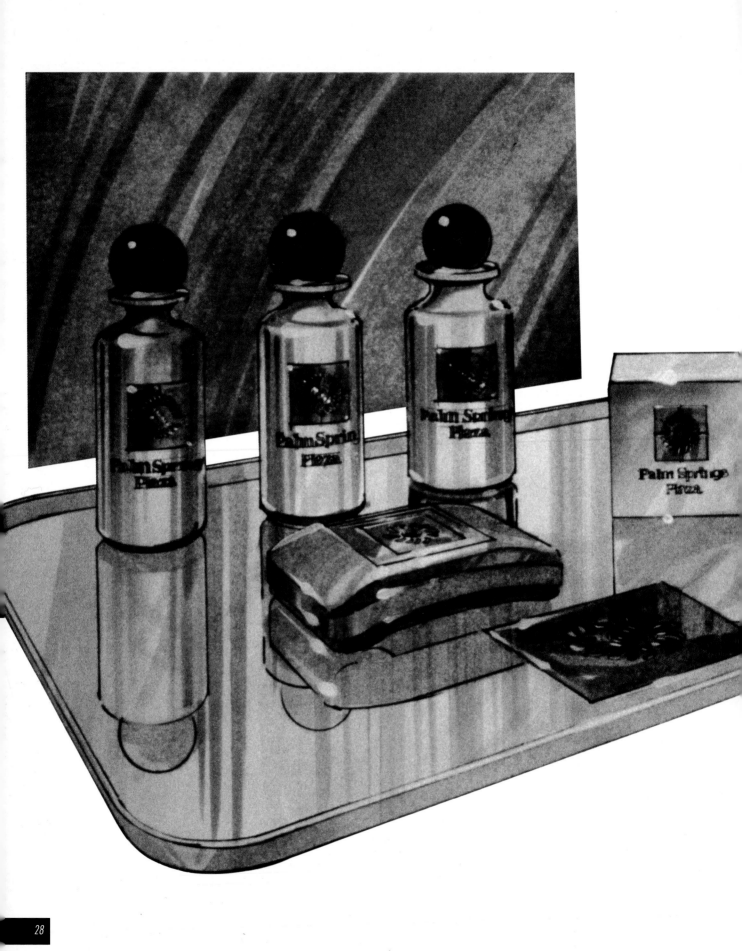

# RENDERING BASIC SHAPES

Rendering basic shapes in an exciting, eye-catching way is the basis for good marker sketching. In the first chapter, you have seen how the most advanced marker techniques are in fact the assembly of very simple, basic techniques, built up step by step. Now you will see how the most basic shapes form the basis for more complex ones. Basic shapes are not only fun to sketch, they can provide a stepping-stone to more advanced work.

Examine the product study shown, and notice how it is simply spheres placed on top of cylinders, standing next to a cube. You will find that the shapes practiced in this chapter will become elements that form a great number of the subjects you will eventually be sketching, not only in the exercises described throughout this book, but throughout your career. Understanding how to analyze a subject according to its basic shapes will enable you to realistically render any assignment that comes your way.

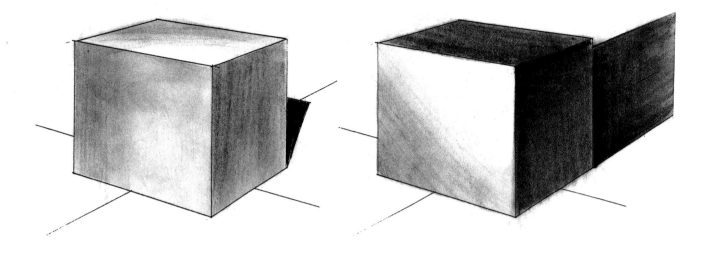

Let us begin with the basics of shading a cube, which is the foundation of any sketch's value plan. If you examine the furniture in a room, for example, you will find a variety of sizes and shapes, yet all the pieces would fit in an appropriately sized box or shipping crate. The value plan of a sketch is the overall concept of how the light and shadow describe the room or object being sketched.

Your perceptions about size and shape directly relate to how light describes an object. The value plan enables you to decide how to best show your subject. Is the light source above the object? If so, shadows will be directly underneath it, and the top of the object will be the lightest shade (or value). Is the object dark or light in its overall tone (or color)? The darker the object is, the more tonal value (or deeper the color) on it overall. Is the light source bright or dim? The brighter the light, the darker the shadow under the object.

Notice how each side of the cube that is visible is a different shade or value, even though they are all painted the same color. The values can be assigned a number, from one to three. The side that gets the most light is the number one side, and that this is the top. The next darkest is the number two side. This is the one we see the most of, and it is the value that would show texture and detail. Finally, the side of the cube that is turned farthest from us is the number three side, the darkest.

You can achieve a great deal of shading by letting one coat of marker dry, and then apply a second coat. You can extend the value range of many colors by using the appropriate gray, warm or cool, that is slightly darker than the marker color.

This is the basic lighting concept, a vocabulary of shading, and with variations it should be in your mind every time you approach the shading of a drawing. A sketch that does not have a clear lighting plan will not "read," that is, it will not communicate a clear and realistic message to the viewer. You are describing an object (or objects), detailing its color and finish, overall shape and size, and any unique characteristics it may have. Use the tools at your disposal—light and shadow—to tell as much as you can, as well as you can.

In practicing the strokes shown in Chapter One, you began developing a feel for the limits of marker technique, including the time it takes for marker to dry on vellum, and the size of area on which you can comfortably connect your strokes to make a smooth wash of color. It should have become clear that you can only fill in a limited area at a time, and that no amount of finesse can enable you to color in a large unbroken area. You can either limit the size of your sketch to one small enough to color easily in one stroke, or refine your strokes to make them acceptable on larger areas.

This leads to the next step in refining your technique: to make strokes that define shape. Look around you and you will observe that even smooth, flat areas are rarely evenly lit. Most objects have shadows or reflections on their surface, and we unconsciously expect to see them.

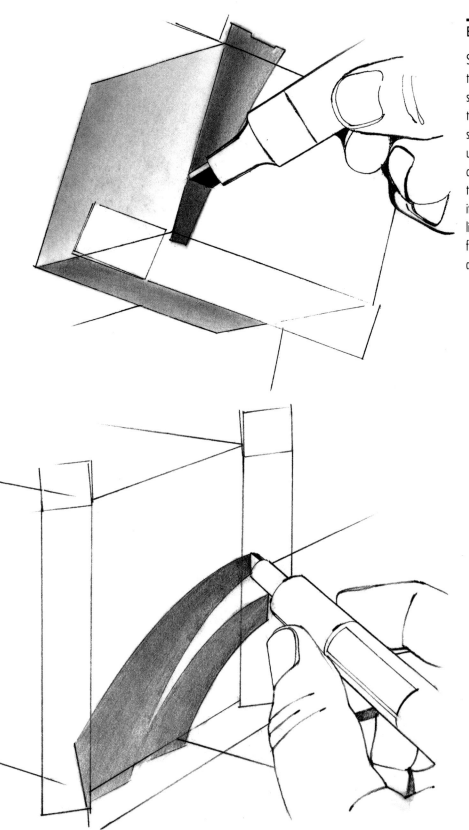

## EXERCISE ONE: THE SMALL CUBE

Shade the top of a simple cube, which is normally the number one, or lightest, value. Next shade the side you see more of, the number two value, and then shade the number three side. If the cube is small enough, you can easily make smooth, unbroken value patterns over the entire side. As the cube becomes larger, it will be more difficult to fill in the whole space. As you cover a whole side, before it dries, come back with a tissue and "pick up" any little puddles of color left when your marker lifted from the paper. This will also help vary the value on a given area, emphasizing the turn of a corner.

### EXERCISE TWO: THE LARGE CUBE

Repeat the steps used on the small cube, using strokes that are not totally connected. Study the example shown here, and observe how the pattern of color describes a flat area without being smooth and unbroken.

Wipe the area with tissue as soon as you have lifted the marker from the paper, removing any unwanted puddles of color. You will learn to keep the tip of your marker on the paper as much as possible to avoid these. Tissue is the most important tool to use with markers, and it is best not to reuse it as the colors will mix and smear.

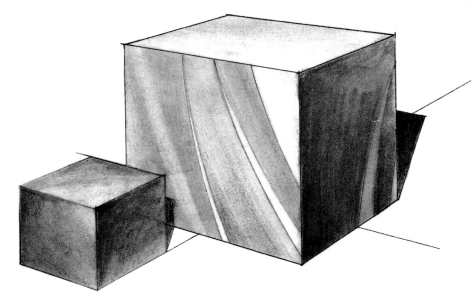

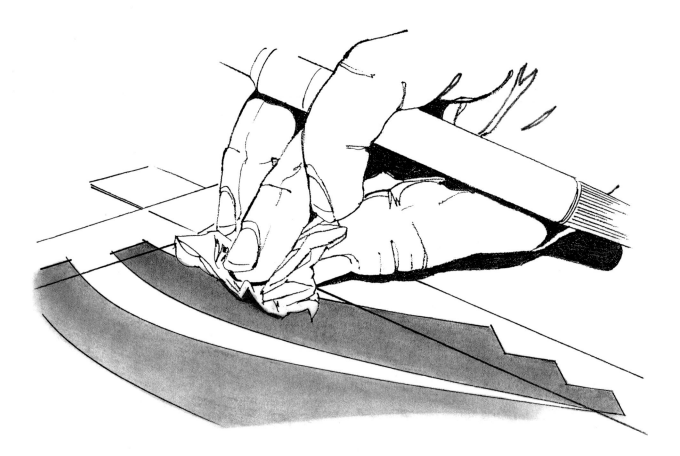

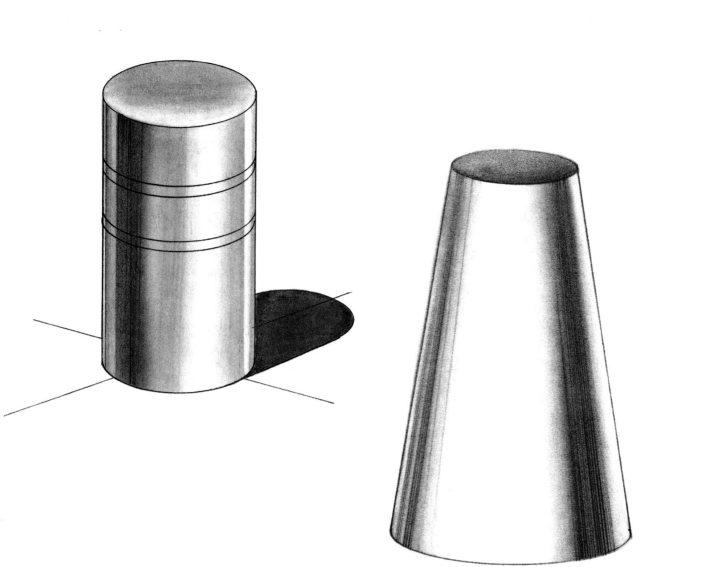

### EXERCISE THREE: THE CYLINDER

The next shape to practice is the cylinder. Notice in the detail enlargement that the shape of the bottle is defined by how it is shaded. The darkest part of a cylinder is called the "core," and it is of consistent width. If the cylinder itself varies in width, as it would with a cone-shaped subject, you can show the viewer that, although varied, the width is continuous by making the core a size consistent to that of the cylinder surrounding it. This size is best determined by following reference material that shows a similar cylinder, and using the size of its core as a guide.

To practice shading a cylinder, photocopy a simple line drawing of a cylinder onto vellum, and shade it as shown. Turn the sketch so you can shade side to side along the entire length. As soon as the core is the right width, use a tissue to rub the last strokes to blend and soften the transition to paper white.

You will find through experience that the illusion of roundness is enhanced by not shading all the way to the edge of the line, and that the smoother the transition from dark to light, the more matte in finish the object will appear.

### EXERCISE FOUR: THE SPHERE

Draw a large circle, photocopy it onto several sheets of vellum, and shade it into a sphere. Try working in different sizes, and notice how much more control is needed to stroke in a curved "core." You will see how much more real your sphere looks if you curve your strokes to match the outside circle.

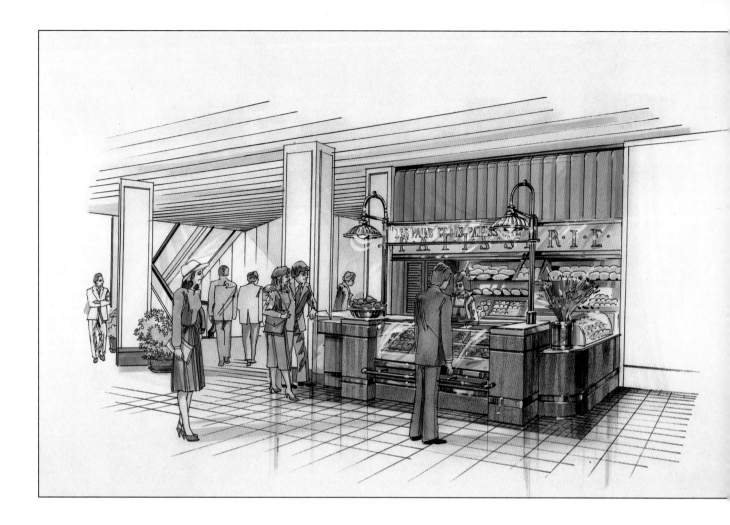

## EXERCISE FIVE: MAKING COLOR WORK FOR YOUR SKETCH

Using additional copies of the same line art used in the previous exercises, try making different colored cylinders. Make them reflective. Develop your skill of observation; observe what makes things "read" as round. Try reflecting color onto one side, and then on the other.

Notice the display case shown above—there is a sharp corner and a round corner. The use of the core in the turn of the right-hand edge of the display helps to accentuate its roundness.

Painters have known for centuries the enhancing effect that warm and cool accents have on the center of interest. Try reflecting a pale yellow onto the top of an object, and pale blue from the bottom. These colors can be added after initially coloring the shape, and it is possible to sketch them on the back of the vellum. Remember to experiment. You can make as many copies as you like, observe what works best, and add each new technique to your repertoire.

The best "blender" to use is the marker color itself, which you work while the ink is still wet on the page. Berol makes a blender marker, and it will help you to correct and smooth your curved areas. Keep in mind that the best results come from your initial efforts at blending; it is easy to overwork an area.

Practice removing a color (yes, it is possible). Tape an area and, working with different markers, wet the area thoroughly with ink, then blot with tissue. You will soon learn how much you can correct, and when to patch instead. This knowledge will help you to know when to color right over an area that will be colored differently later. This is important, as the smooth strokes of an overall carpet area can then usually go right over the legs of the people standing on them.

Changes are a reality in every aspect of design. When you are working in pencil, a change at the line-drawing stage is not a big disaster. If you wish to change an electrostatic copy before you color it, there are solutions available to eradicate the line. Hampton Products H-P no. 150 Diazo Solvent works well, and Teledyne-Post makes a felt-tip pen called Image Dissolve that removes line as well.

**1**

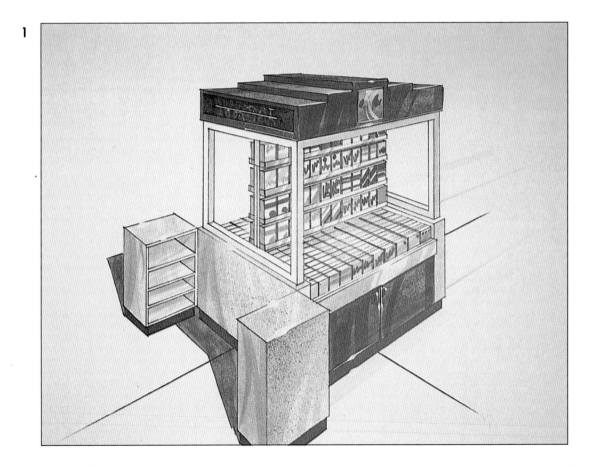

**2**

**3**

**4**

1 Erasure is not as simple a solution after you have colored your sketch, so here is a simple way to make a change on your finished art. The top and sides of this display's roof must be changed to white zolatone.

2 The blue is too dark to simply mop out (although this is possible with lighter colors), so take your original line drawing and make a new photocopy onto vellum of the area to be changed.

3 Color and texture the area on the new copy you have made. Do not be concerned about color straying outside of the part to be changed. Then spray-mount the vellum to white paper, and apply rubber cement to the back of the paper.

4 Cut out the changed area only, taking care to save the boundary lines. Use a sharp X-acto knife and a steel rule.

5  Apply rubber cement to the area to be changed on the original sketch, and let it dry.

6  Carefully pull up the new top, and apply it onto the original sketch, making sure the lines match.

7  Remove all excess rubber cement with an artist's eraser, lay tissue over the patch, and rub it firmly with a roller or broad-edged rule. Notice how the patch, if properly done, becomes invisible to the eye.

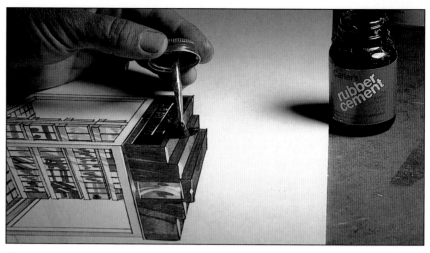

**5**

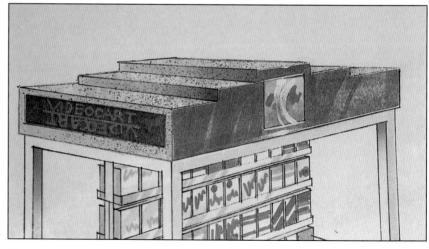

**6**

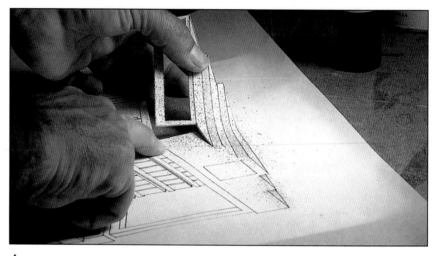

**7**

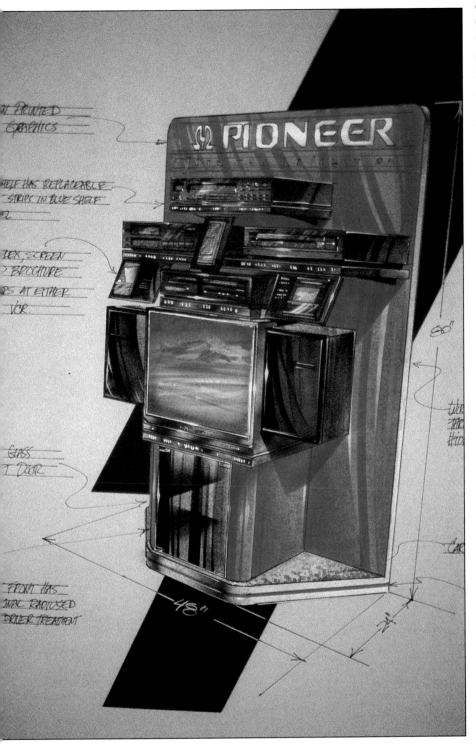

A patch works best when it fits within lines already drawn on your sketch. You can also splice a correction in if your drawing is not dry-mounted as this one was. The splice is done the same way, except it is laid over the sketch, taped down in careful alignment, and both pieces are cut through. Then the old part is removed, and the new part is taped from the back with frosted tape (frosted 3M Magic Mending tape works well for this).

You can adapt this technique to solve most of your change problems; however, if the changes are too extensive you might be better off saving yourself time by preparing a new sketch.

Cutting out a sketch is another way to vary your technique. This drawing was colored on vellum, spray-mounted to white bond, then cut out at its outline. A medium-tone gray mounting board with a black zig-zag was prepared, and the marker sketch mounted to it.

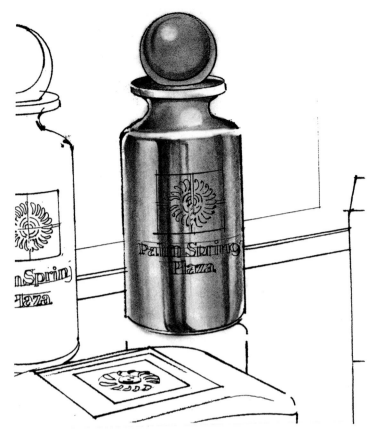

The basic shapes you have practiced are, in one form or another, present in every sketch you will ever create. Learn to analyze your chosen subject, break it into its component parts, and apply the skills you have already learned. Remember to turn the sketch so you can make the smooth, easy strokes that are the trademark of the master sketcher. Ruin ten exercises, so the eleventh will be a "keeper." Save the ones that work, throw the failures away. Make a notebook of your exercises, noting the markers you used on the back, and see how quickly you will be reaching for the colors that you know will work for the sketch you have at hand.

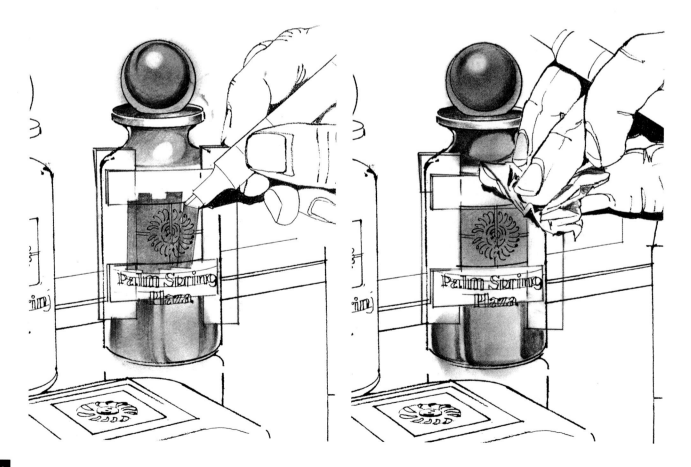

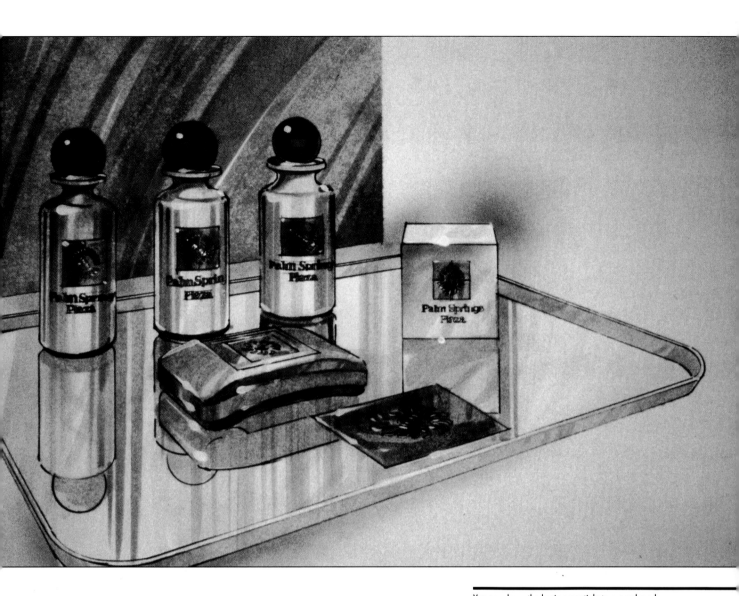

You now have the basic essentials to a good marker sketch. Remember the following rules: One, for a sketch to "read" correctly, it must have a lighting plan. Two, you control the lighting plan of your sketch; use it to define and describe what you are drawing. Three, if the sketch is not exciting to look at, applying the first two rules will not help.

# SKETCHING PRODUCTS

Learning to create an effective product sketch is the first step in putting the previous lessons into practice. In this chapter you will find that sketching products is really an extension of the drawings you have made of basic shapes, and that you will be adapting and applying the techniques explained in the previous chapters.

Every small appliance you use has been drawn in a design studio somewhere, tens, if not hundreds of times. Hair dryers, electric shavers, blenders, toasters, cameras, television sets—the list is endless. Design of these products represents a substantial and important industry. Some large manufacturers have their own design studios, while many others hire outside design firms. Common to any of these studios is the product sketch, a simple drawing of one object, devised to show the product to its best advantage.

Simplicity is the key to making a sketch successful. Remember to use the basic lighting plan that is so essential to describing the shape and finish of your product. Think about how to show the object to its best advantage. What angle of view will be most descriptive? Light should come from above, but from which side? Making these decisions is establishing a lighting plan. Collect scrap photographs for reference and observe where the light source is.

Once you have become comfortable doing the simple sketches shown in this chapter, you will find you have the basic skills for doing more complicated drawings.

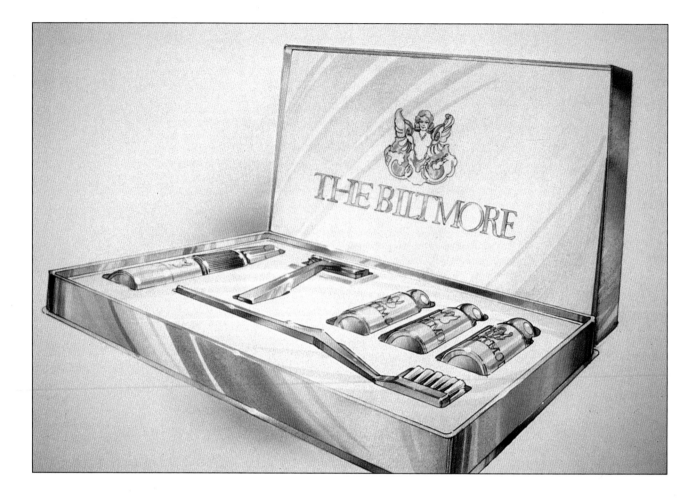

Analyze the simple sketch of a hotel amenities package shown here. Every shape can be seen as one of the basics studied in the previous chapter. The colors and finishes shown are not accidents. Design selections were made, then marker colors selected that were the closest to samples of the actual materials. To select marker colors, compare your color chart with the sampels you have available. Once you have decided on the color of marker, you then begin your rendering of the shape. Remember that you can stretch the value range of any wet marker color by rubbing the surface quickly with tissue, or letting it dry and adding a second coat. Warm or cold gray can help extend a value range, as can working on the back as well as the front of the vellum. Coloring a design study is basically simplifying it, analyzing the shapes, and selecting the best source of light to show off the design.

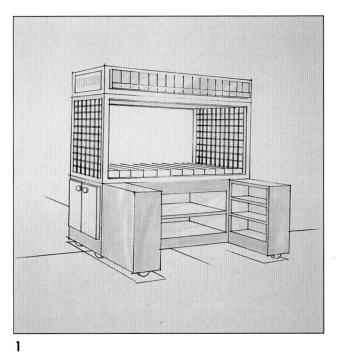

**1**

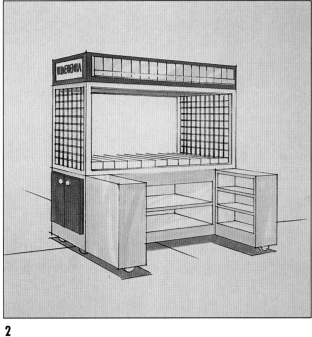

**2**

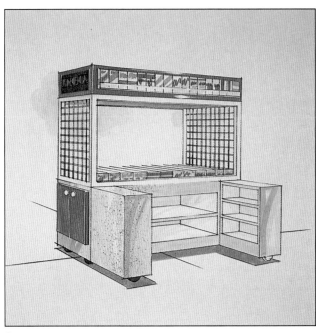

**3**

1  The lightest colors are established first, with care taken to "turn the corner"—that is, to make clear a change in surface from side one to side two to side three. The darker color is established next, using the same lighting plan as for the light, white areas. In this example, the light source is above and to the left of the subject. The number one side is the top of the two cubes, the number two side is the left, and the number three side is the front.

2  Finally, any additional details are added, keeping to the same overall lighting plan, and highlights are applied to give the finishing touches.

3  Take care to describe the design correctly, but also present an exciting picture. Highlights, reflections, and dramatic lighting all help to give the necessary punch to a sketch. Sketching is communication. You have a great idea to show to a potential client who you want to become excited too. In the vender cart shown, every opportunity was used to add interest to reflective surfaces and emphasize contrast between colors.

Examine the simple vending cart shown—it is a basic design study. Also shown is an adaptation of the simple cart, with the top and central display system changed. The same drawing was used, copied and reversed, then modified to "customize" it for the client. Only the changes needed to be drawn again, *not the whole sketch.*

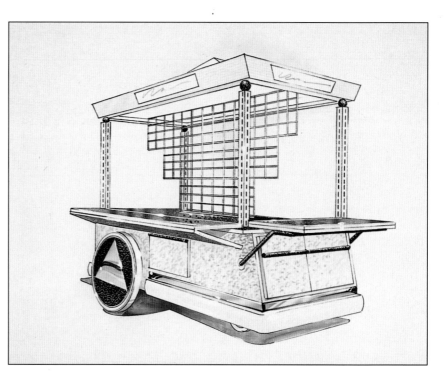

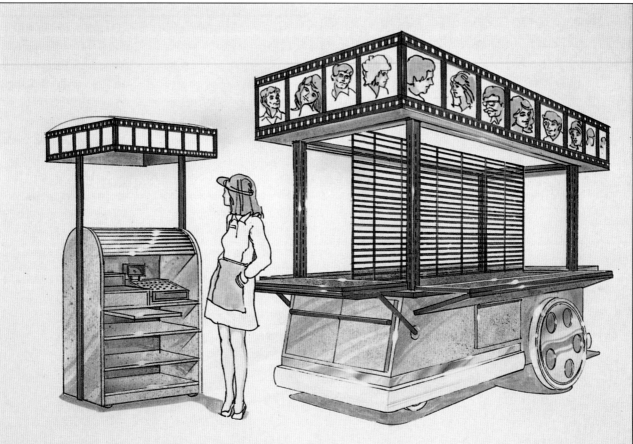

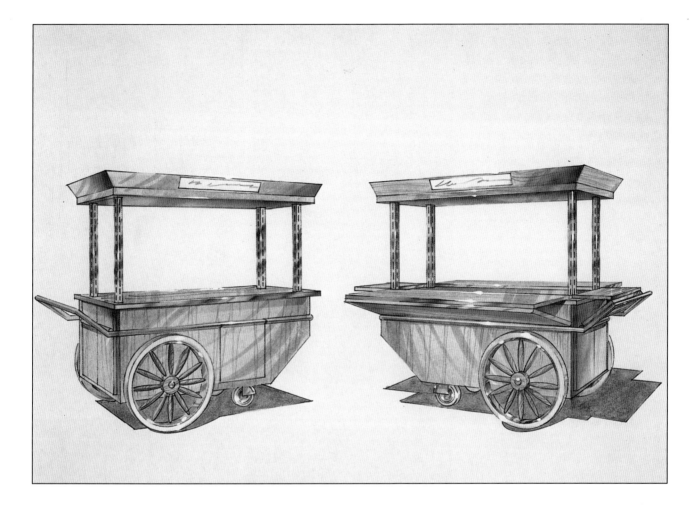

This study shows the same basic cart from two sides, with only minor variations. The first drawing was copied onto clear Mylar, which can be bought in 8½ x 11" (21 x 28 cm) sheets, using an office copier, then reversed, copied again on bond and changed, then taped next to the original cart on a large sheet and the combined sketches copied onto one sheet of vellum.

Once you see the possibilities, you will find your own time-saving tricks using the modern tools at your disposal. Notice that no creative step has been lost; rather, repetitive steps that take time away from design have been reduced. You could make three sketches in the time it used to take to do one, and they will be better sketches. Different color schemes can be shown, and you have the added security of knowing that if something happens to your final art, you always have the pencil line drawing on file.

1  Markers have the reputation of being limited in their ability to show a range of value within a given color. This can be true, but only if you let it. Examine the color sequence shown and notice that the color was established early in the sketch. There was only one marker that matched the actual finish shown, Teal Blue no. PM-38. Once the basic lighting plan was established with the correctly colored marker, other areas were added.

2  Ground texture was added, and highlights begun. At this point, the sketch as a whole was analyzed, and areas that needed added value range were given a "boost" with the aid of marker airbrush.

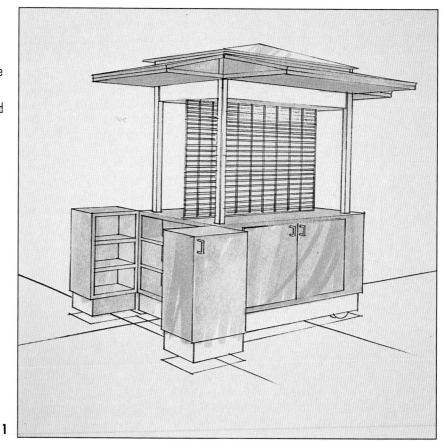

**1**

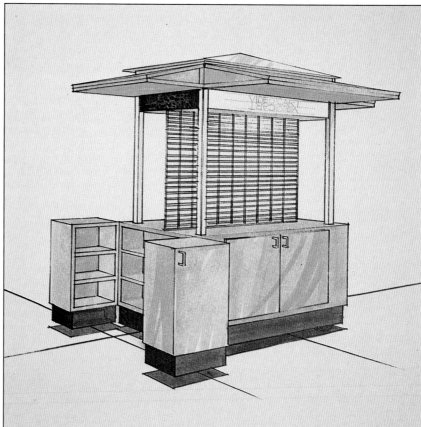

**2**

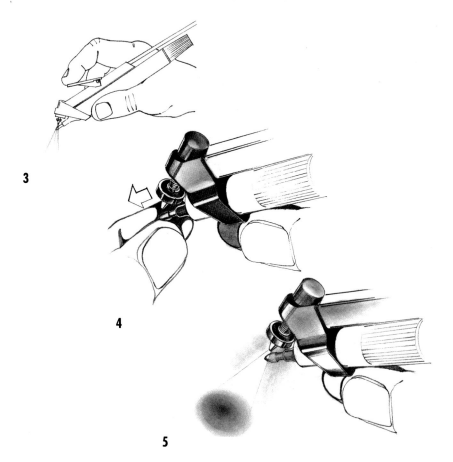

**3**

**4**

**5**

3 Marker airbrush is simple to use. This is one is called the "Letrajet." It is made to be used with a different marker line, but your Berol Prismacolor marker will fit with little effort.

4 Pull out the fine tip until the air blows across it.

5 Use Post-It brand notes to mask off areas, and emphasize the corners. Be sure to start the airbrush on a sheet of paper next to your art, then spray onto your sketch. *Never start the airbrush on your sketch until it is emitting an even spray of ink.*

6 Compare the sketch shown before the airbrushing and then after. Notice how every effort was made to emphasize the corner turns before the airbrush was used. The lighting plan did not change; the number one side is the counter top, the number two side is on the right-hand side, and the number three side is on the left. The small change produced by the airbrush dramatically improved the range of value on the drawing, and emphasized the shape, thus giving the sketch as a whole much greater impact.

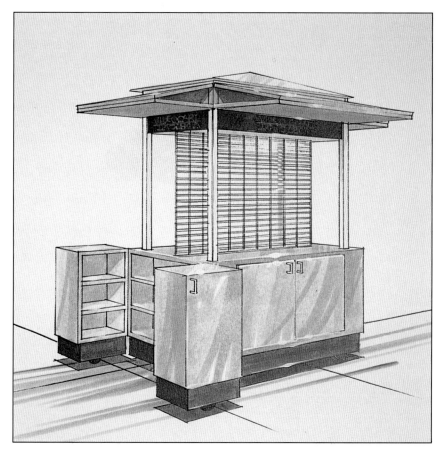

**6**

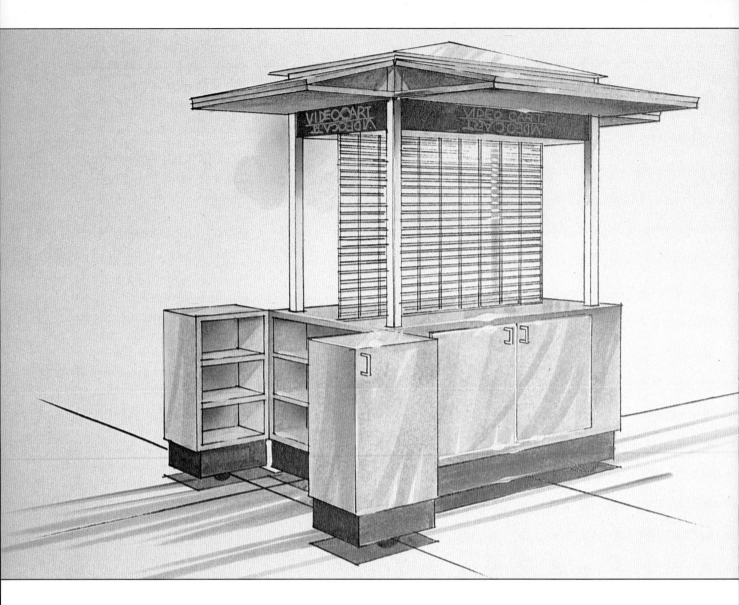

Notice how little it takes to greatly extend the value range of the one color available. A 90 percent cold gray marker was used to add the shading at the corners. Prismacolor pencils also help to add that extra value (in this case, a dark cold gray). If you find only one marker that is the right color, start by applying it to the vellum as lightly as you can, then rub it with tissue, emphasizing the corners of the shapes. Other value-changing techniques to try include adding another coat of the same color, coloring on the back of the vellum with the same color, or adding dark gray (warm or cold depending on the base color).

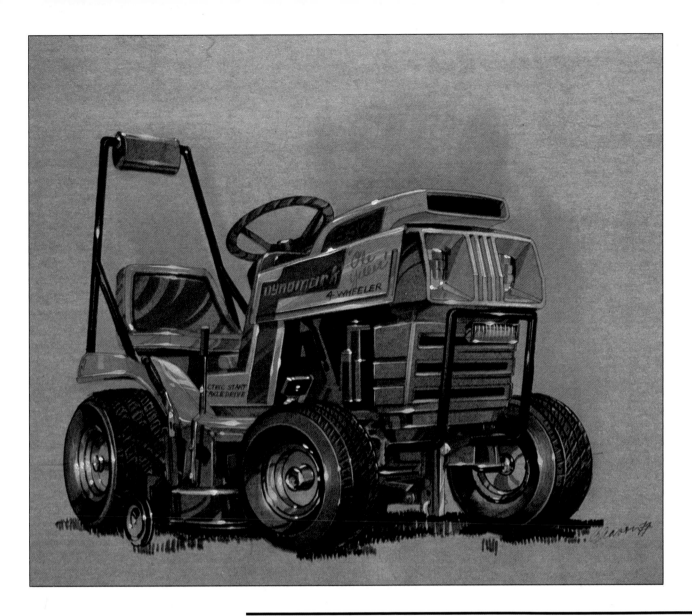

Experiment with other reproduction techniques—this drawing was done on a sepia intermediate (nonerasable) surface to give the line a soft look and achieve a warm background.

You can learn many new techniques through experimentation. Take a simple pencil drawing and try a variety of papers. Pantone paper can be run through a large copier like a Shacoh or Xerox 2080. Marker works on this quite well, and Prismacolor pencils can really help add punch. Be sure to copy your blank color chart onto the same paper, and make a color chart that tests your markers on the paper you are using. This becomes your new palette, and experimentation is the cost of a copy, not the whole new line drawing.

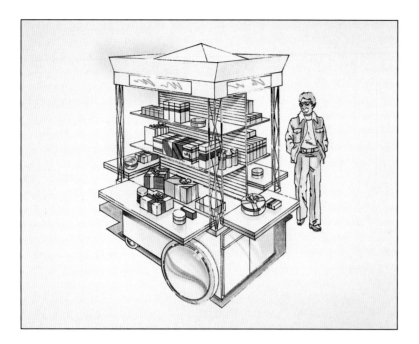

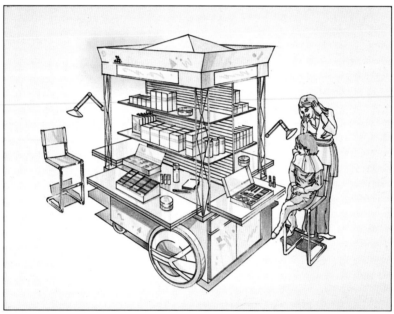

A different point of view can dramatically change the way a design looks on paper. Sketches usually take the view of eye level, for which five feet (one and a half meters) is the accepted standard. However, you may wish to show more of the top of the design, and therefore select a higher vantage point. In this example, the central display area is featured, and a high viewpoint helps to direct the viewer's attention.

The client wished to see two versions of this study, so the basic design was drawn without filling in the display, then a copy was made on vellum. The first drawing was finished, then copied onto vellum. The copy of the unfinished original sketch was completed as the second version, and also copied onto vellum. In each case, the underlying cart remains; only the products displayed and the people shown are different. Both sketches were then colored and mounted, taking about one-third less time in their completion than two complete line drawings.

1

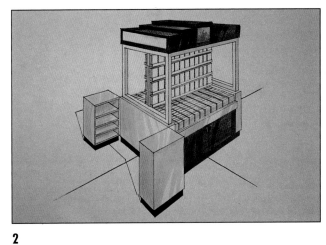

2

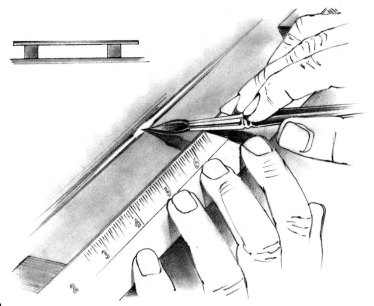

3

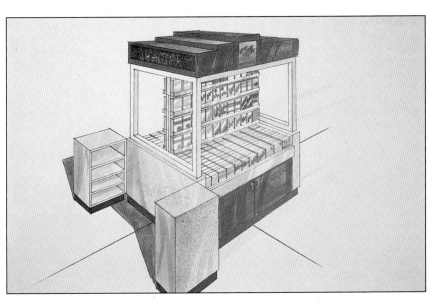

4

In both the previous examples, the product was basically all one color and light in value. This sketch shows how to deal with the contrast of two different values or colors placed next to each other.

1  This design required a basic white shape with dark blue accents. The white value pattern is established first, making sure the corners "turn," and the number one, two, and three sides are established.

2  Next, the blue areas are laid in, following the same value pattern established for the white areas. At this point, it becomes clear that the values on the white area need to be emphasized.

3  Shadows help to accentuate the whites, and marker airbrush with a 90 percent warm gray is used at the corners to help push the contrast in the white cubes.

Highlights help to dramatize the central area of the sketch, and emphasize the change in value at key areas of the design. Highlights can be applied in two ways; with a white or cream Prismacolor pencil, or with white tempera paint on a pointed round watercolor brush.

4  Tempera should be the consistency of thick cream, and applied with a no. 6 or no. 7 red sable round brush. Practice making lines using a bridge (the one shown is a wood ruler glued to two art gum erasers) on a separate sheet of paper. If you have problems with the tempera bubbling, try mixing the paint with a little soap—it works!

Notice that even though the subject of this sketch is not one basic shape, it is made up of several basic cubes, and each is shaded with the technique you learned in Chapter Two. As you progress to more and more complex shapes, you will find that you can still use the basic lighting plan, adapting it to show off the best aspects of each new design.

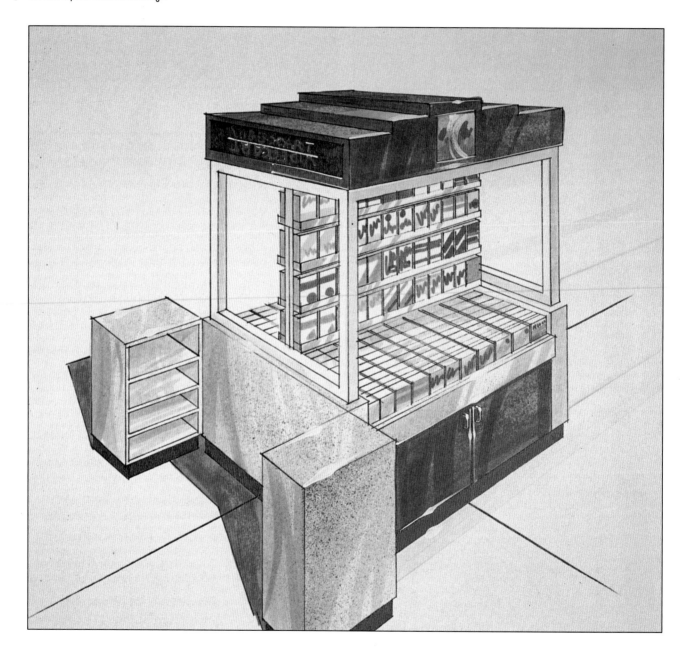

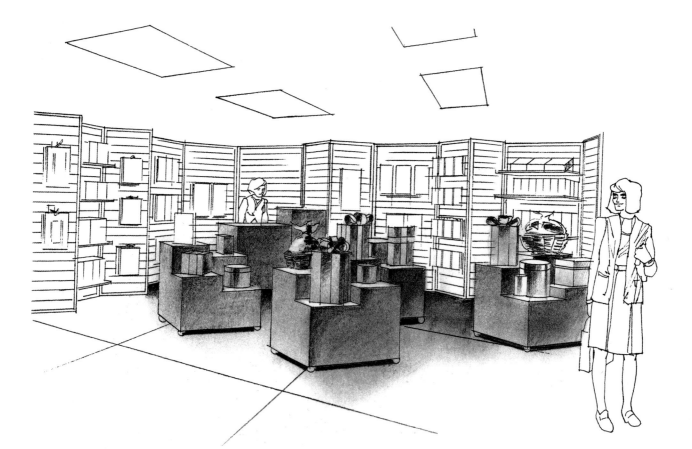

Each sketch should have its own internal logic. Once you have chosen a light source, be consistent. Consider the best lighting to use before you start to color. *Think* while you color, analyzing the way you are developing the shapes you are describing. Shadows can be used to show the direction of light and to add drama and information in the sketch. In the accompanying illustration, notice the display system is basically a series of cubes. A simple lighting plan was chosen, with the light source directly above. This meant the tops would be the number one (lightest) sides. The only remaining decision to be made was between the number two (medium), and number three (darkest) sides. Normal practice makes the smallest side number three, but that was not followed for this sketch. The number two (medium) side would show the most detail, that is, the texture or pattern,

but as there were no textures or patterns present in the sketch, greater interest was created by making the larger, right side, the number three (darkest) side. Once this decision was made, the shading of the displayed products followed the same logic.

You will find yourself thinking of new ways to feature your design studies—the opportunity for creativity is endless. Even if you think that product sketching may not seem to apply to your specialty, you will find the principles involved here apply in each of the following chapters. As you continue through the exercises that follow throughout the book, notice how everything you need to sketch responds to the use of the simple lighting plan shown in this chapter.

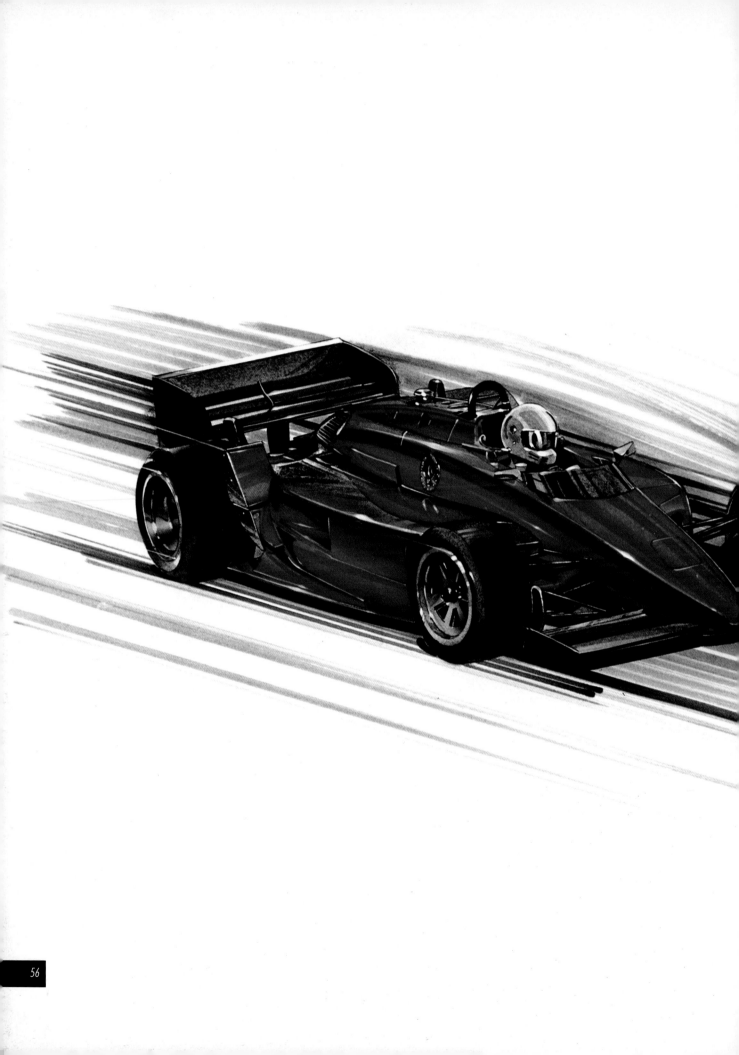

# SKETCHING AUTOMOBILES

Cars are among the most exciting of all the sketching opportunities. You may have envied a dramatic sketch seen in a magazine or catalog, and felt that you could do just as well. You can, but you must first learn the basics. Automobiles are as complex in shape as the human form. In addition, they are covered with reflective surfaces. You cannot use a T-square and triangle to assist you, as most aspects of a car's shape are curved. To make matters worse, most people are familiar with the many makes and models of cars, so accuracy is of prime importance.

Developing an acceptable marker technique for automobiles requires an investment of considerable time. You will need to develop a scrap file of reference art for different makes, models, and viewpoints. Since the sketching of cars requires a lot of practice, it is best to decide how much importance cars have in the sketches you do, and establish an appropriate time priority. If cars appear regularly in your work, taking time to learn to draw them right is a worthwhile investment in the overall quality of your sketches.

If you are drawing a sketch of a building, the parking area will look empty without parked cars. Or your goal may be to simply show one of the many daily activities done in a car, or near one. Regardless of the circumstances, you will want to draw the best car possible, as the viewer will be distracted by a poorly drawn or badly colored vehicle.

Tracing ads or photographs is the quickest way to develop your technique, and you can do so while producing finished art. Few illustrators expect to be able to draw a car from scratch, and you should feel no hesitation about tracing an outline from your scrap file and using it as the foundation for your finished art.

There are many sources of scrap art for cars, and the most practical are those that provide you with up-to-date models. The local newspaper is usually a great source for line art. Look in the classified section and you will see that new car dealers are provided with line art from the manufacturers to use in their advertising.

Take the time to tear out pictures from magazines, newspapers, and catalogs. Annual new car shows are an easy source for updating your scrap file; they will give you an opportunity to make observations and take your own pictures.

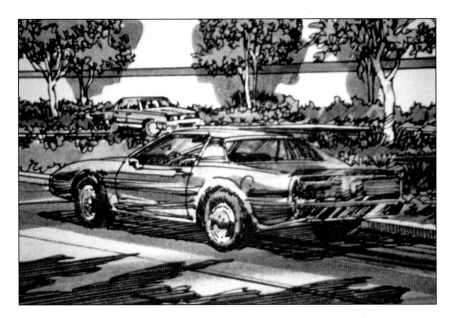

Observe the cars shown. They are all portions of larger sketches and contribute scale and drama to the overall sketch. Had they been poorly drawn, or in the wrong perspective, an otherwise competent sketch would have been ruined. Be aware of the overall viewpoint in your drawing, and be sure the car you use is appropriate in both size and angle.

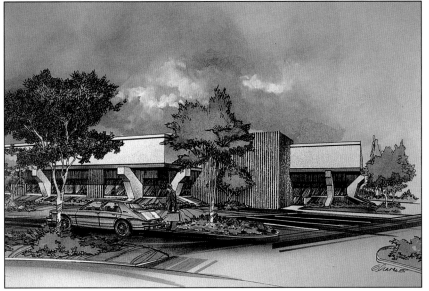

1

2

3

1  Make a habit of cutting out drawings of different cars, and you will soon have an extensive scrap file. You can also enlarge these pictures and drawings to use for practice as you develop your own line drawing ability. Trace these drawings to learn how the complex curves of a car are best drawn.

2-3 You should also begin to collect different french curves. These guides are a wonderful addition to your tool box and will aid you in your own drawings of automobiles.

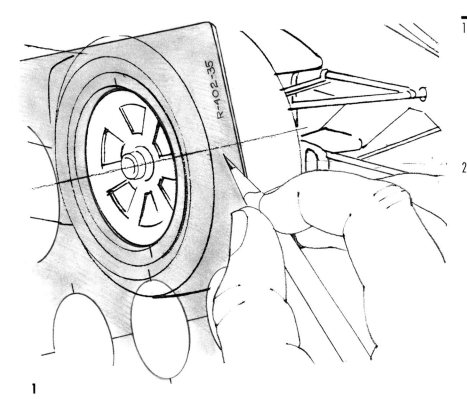

**1**

1  A set of ellipse guides will be of great help to you in drawing wheels and tires. In the example shown here, you will observe that the axis line through the center of the ellipse can be best understood as the axle of the wheel, and all of the ellipses are drawn with this center line aligned within them.

2  Notice how the tire is simplified to make shading easier. The light will hit the top of the outside of the tire, then the wheel, then the top of the lower inside of the tire. This lighting plan is interrupted only by the shadow of the wheel. The tire is usually colored warm gray, and you will find 90 percent warm gray, or black, works well. Try using 90 percent cold gray for your shadow and wheel well.

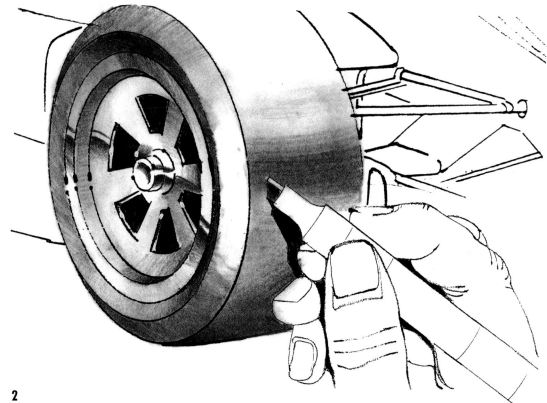

**2**

The car is usually seen from the eye level of a person of average height and most ads show the car from this angle, but be alert for more exaggerated angles, which are difficult to use in an architectural sketch. Observe the two details from a car show drawing: one car is at a normal eye level, and one is on a platform, requiring a low angle. The lower angle means the viewer will see more of the underside of the car on the platform, so examine your scrap and notice what you see more of, the roof and hood (from a high angle), or one of the sides or ends.

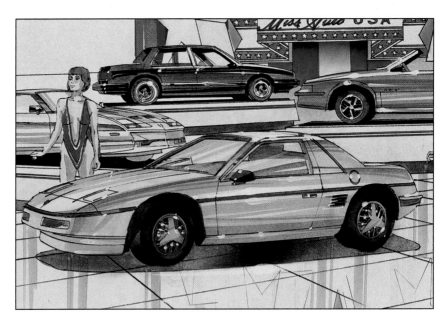

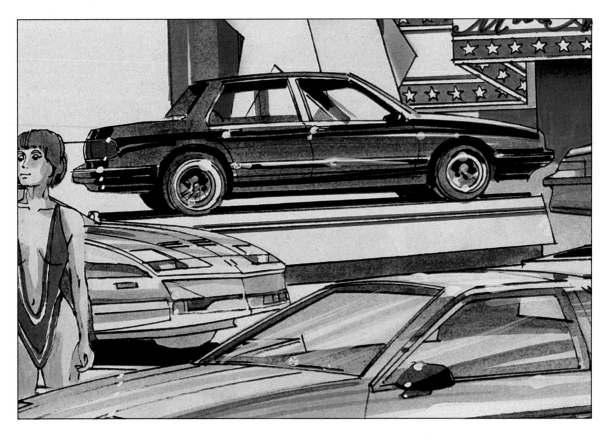

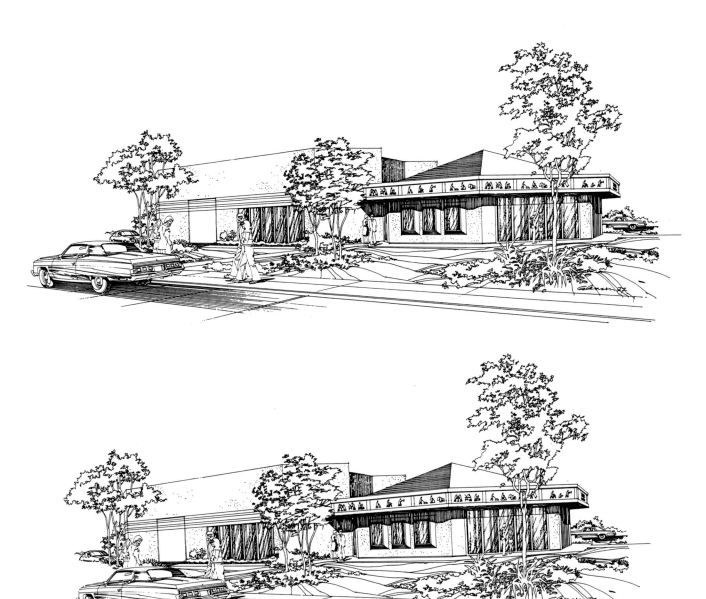

You should strive to adapt your scrap to the eye level in your drawing, keeping aware of the proper scale for your chosen car. The perception of size is controlled by the placement of the car in relation to the horizon line. If your car seems too small it should be shifted up closer to the horizon line. Try placing your scrap-art reference under your drawing, shifting it up and down before you trace it. Observe the car in the examples shown. Both drawings are identical, except for the location of the car. The car is the same size in both drawings, but by shifting it to the right, as has been done in the bottom drawing, the car becomes dramatically out of scale. By sliding your reference drawing underneath your sketch, you can carefully find the correct location before you trace it onto your drawing. Compare the car to any people standing near it: Do they seem too small or too big in comparison? Be alert to the difference a small shift in location will make in your—and your viewer's—perception of scale.

Cars can be distracting if they are too polished or inappropriate for the rest of your drawing. If you are drawing a medium-priced tract of houses, a Ferrari would seem out of place and divert the viewer from the purpose of the sketch.

The shape of the car is described by its outline, the many door and hood openings, and the reflections that appear on its surface. The door outline is like a section cut through the car, and by examining it, you can see details of the overall shape that you might otherwise miss. If the outline is crisp and sharply defined, the reflections will be more like a flat mirror.

Fuller, more rounded curves will cause the reflections to be more stylized, like a fun-house mirror. Be alert to how the doors and trim should appear, as they will help you to see how to shade the car's body. Select a color for the car that will help your sketch, and apply it in a stroke that travels parallel with the ground.

A realistic outcome is your goal, particularly in architectural sketches, where cars can give a sense of reality to a drawing of a nonexistent building.

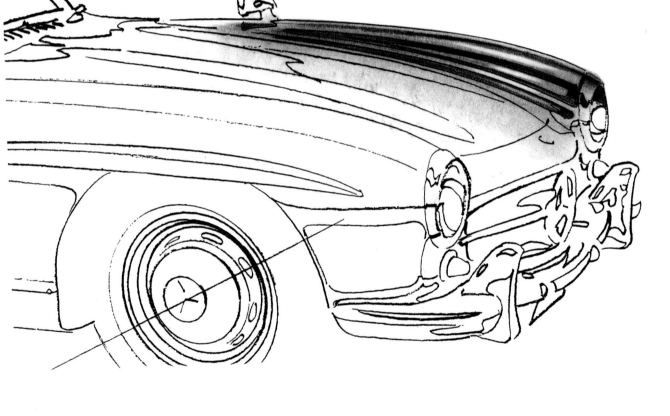

Reflections create excitement in describing the shape of a car, giving the illusion of motion even when the car is at rest. The most dominant reflection on a car is the "horizon line." This is a major reflection across the waist of the car, simplifying and stylizing the distant horizon. It is repeated on the top of the car, in the hubcaps, and on any other reflective surface that would face the same way.

If the car is older, with separate pods for fenders and headlights, a "banana shape" would be seen reflected onto the hood. This is the horizon line being twisted by the reflective painted metal and then repeated in the hood. Using these opportunities to define reflection helps you to show the gloss finish.

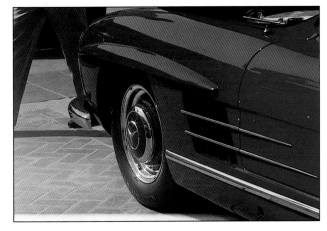

**1**

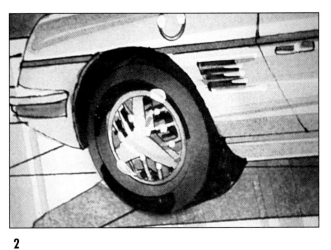

**2**

1-2 Examine the photograph of the car, then compare it to the marker illustration. Notice how stylizing the reflections helps to clarify the shape. No effort was made to copy all the reflections in the photo, only those that helped the sketch.

3-4 These photos were taken at a car show for reference. Observe how the color changes the value, but not the shape of the reflections. You can see the blue of the sky in all the chrome, and in the paint as well. Try sketching your first few cars in black and white only; learn to make the shapes clear, simplify the reflections, and emphasize the lighting plan. Then you will be ready to add the colors that make the drawing come alive.

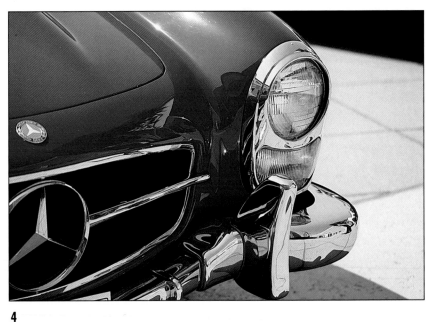

**3**

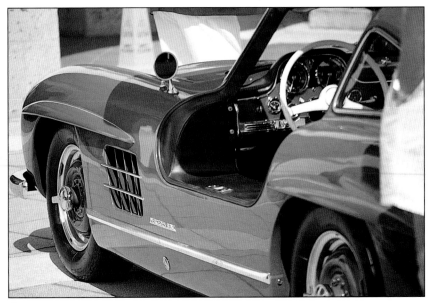

**4**

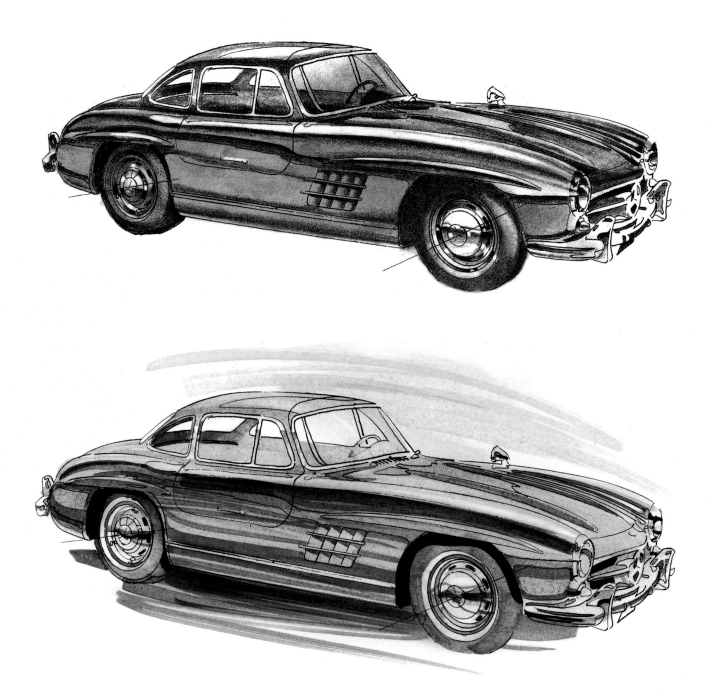

Compare the black-and-white drawing with the color sketch and note the difference made by adding some blue sky and warm earth. This is a dramatic comparison because of the monochromatic color scheme chosen, but it helps to illustrate the impact that using different tones can have on your sketch, regardless of the car's color.

1   Chrome has virtually no color, but certain "tricks of the trade" have proved helpful in reliably depicting chrome in a marker sketch. Designers have found that a blue sky reflection works almost every time, and contrasts well with a warm ground. Analyze the chrome in your sketch, and organize in your mind all the parts that would normally reflect the sky. These get a blue reflection, with a gradation that is similar to the colors of an actual sky.

2   Next, establish a contrasting earth-colored, warm-ground reflection, and shade all the parts that would reflect it. Each chrome part that is aligned vertically would have a horizon-line reflection centered in its middle. This is the basic formula for chrome, and if you analyze any successful depiction, you will usually find a variation of this formula has been used.

1

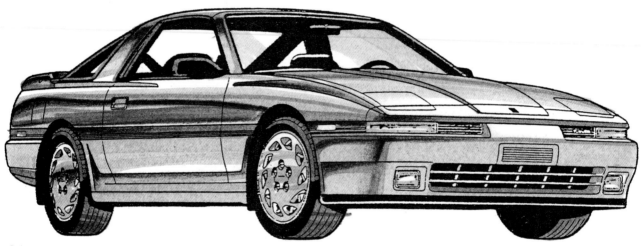

2

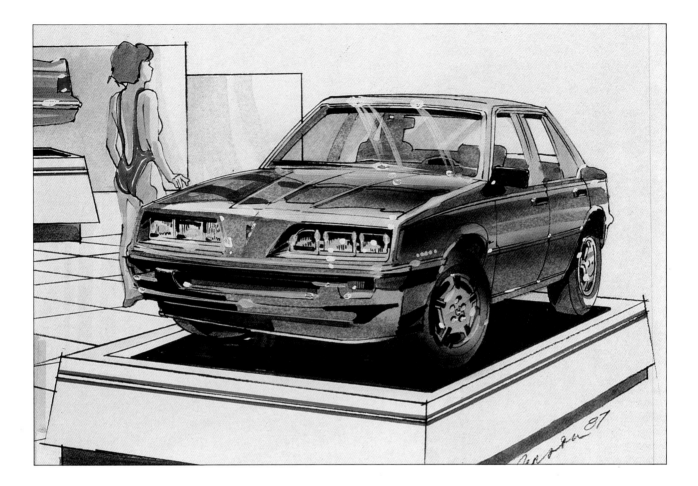

Observe carefully how the sun highlights the car. There is one main highlight and many smaller highlights aligned with it. Use caution in your highlighting; the more you use, the less impact it will have. Cars are very complex. They can be difficult to draw, but their dramatic contribution to any architectural environment rewards those who take the time to draw them right.

Windows are best treated at the same time as the overall highlighting of the car. Glass is basically a semireflecting mirror. You will find a white Prismacolor pencil adds a nice glaze over the surface, and emphasis can be added with white tempera.

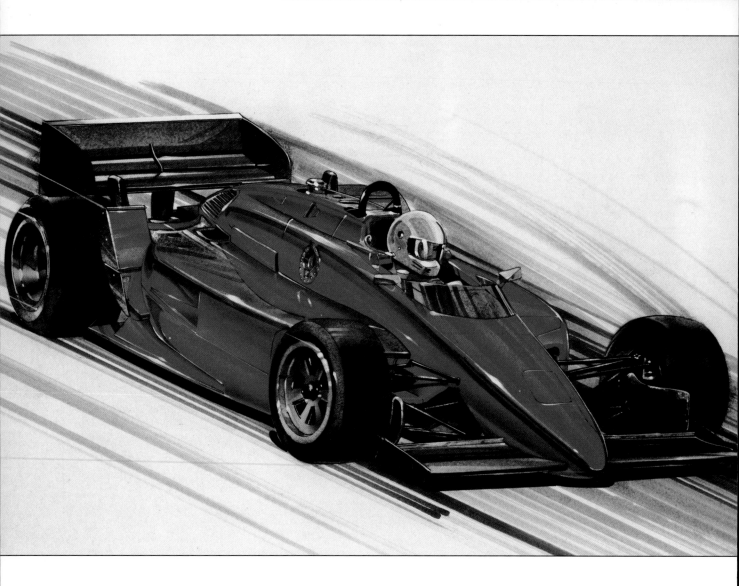

When you look at a car, be alert to the way reflections are governed by the shape of the metal; their direction is controlled by the metal's arch. The mistake most often made is in trying to duplicate exactly a reflection seen in a photograph, when the surrounding area in the sketch is not the same. Learn to stylize and simplify. Make the shapes simple— and make them work for you.

Reflecting color is also important, and a blue sky can be seen in the hood, windshield, and chrome of the car. Review the chapter on basic shapes, and notice how the car has a number one, two, and three side. The change from horizontal to vertical is rarely abrupt, but more likely curved, like the "core" in the cylinder sketch you practiced on page 33. Avoid sharp edges, unless they actually exist.

1

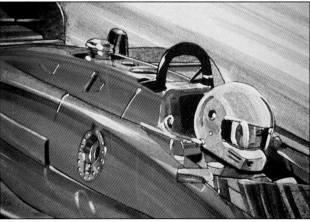

2

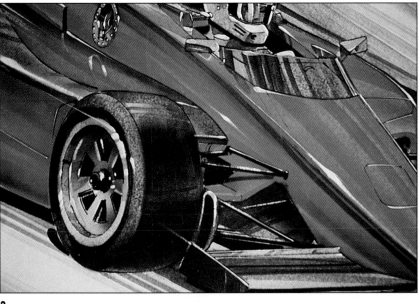

3

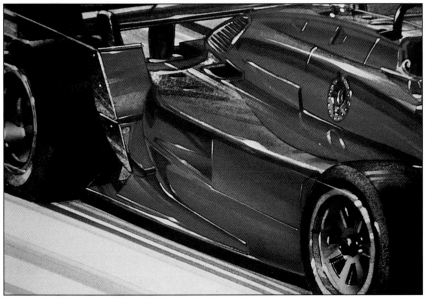

4

1-2 Chrome can also overpower a sketch. For this reason, you will find it is better to save it until last. Then you will be able to judge the amount of impact you need and use the drama sparingly to help the overall appearance of the drawing. Once the chrome is colored in, the next step is the addition of tempera highlights.

3 Highlights are very important to cars, as the lighting at any dealership will confirm. In your sketches, the sun will be the most common light source, and a careful analysis of sunlight will help make the most of it.

4 Keep in mind that the sun is not a singular pinpoint of light, but rather a light source that will vary depending on the time of day you are imagining for your sketch. If the car is the single subject of your drawing, you may choose a more complex series of highlights and reflections than you would if the car is to be an accessory item in your drawing.

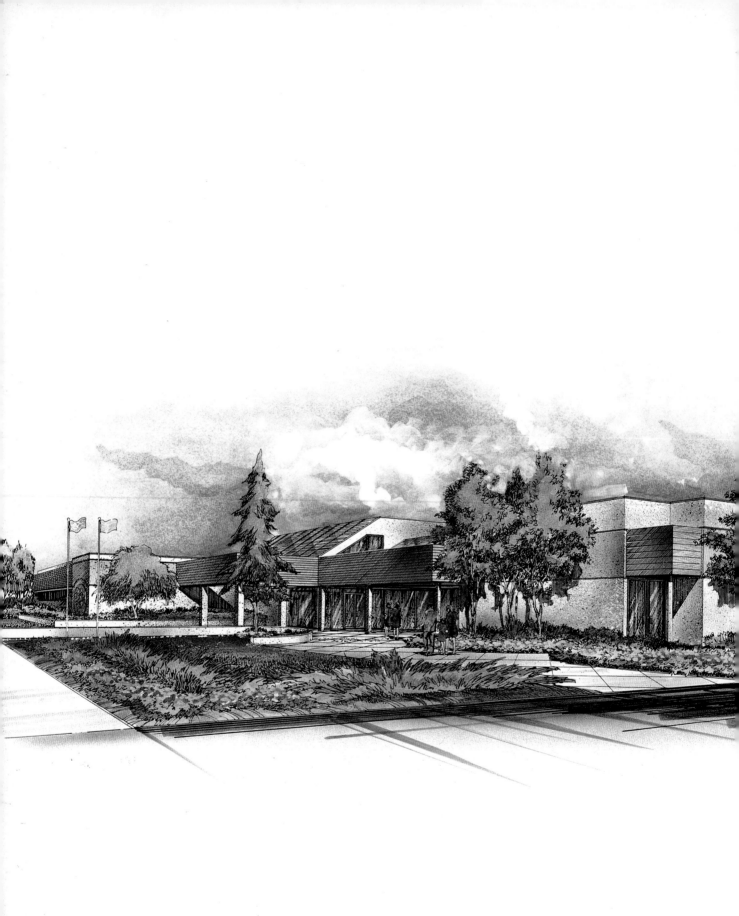

# SKETCHING ARCHITECTURE

Architectural rendering is an important visual communication tool that affects a cross section of society. Planning commissions, bankers, city councils, and investors all base their decisions about the desirability and visual appeal of a project largely on the basis of a rendering presentation given by the designer.

All of the illustrations shown in this chapter were drawn from information provided by an architect or builder. This information is usually a complete set of blueprints created for construction, and the illustrator is actually "building" it on paper. The construction has normally not yet begun, so the plans are the only source of information. Other available source material may be photographs taken at the job site that will show the surrounding area, any views, and so on.

Architectural illustrations are commissioned for a variety of reasons: to raise money from investors, to gain approval from government agencies, or to attract buyers. There is a responsibility on the part of the artist to fairly represent what will be built, yet the words "artist's conception" are still often used as a disclaimer. Such sketches are carefully prepared and executed. The client can take a photo after construction and find it matches a rendering to a startling degree, although the rendering was drawn when the building site was nothing but a vacant lot.

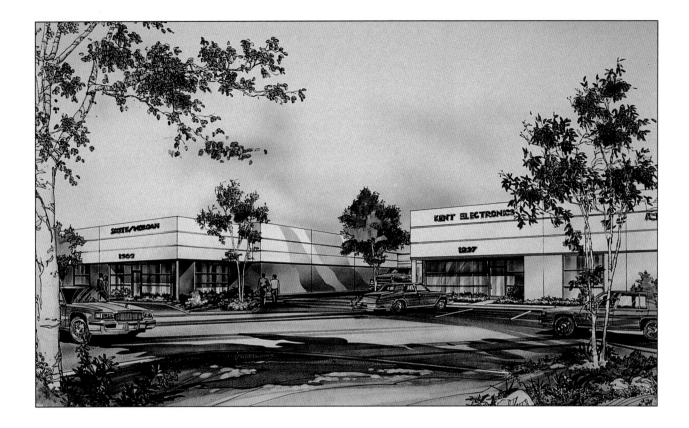

The illusion of reality, as well as a responsible depiction of the intent of the designer, play a part in the production of an architectural rendering. Markers can be used to do a high-quality sketch in a short period of time—they definitely have a place in the designer's tool box. If budgets are a consideration, markers can often allow the artist to substantially reduce his or her price for a finished piece of artwork (especially in comparison to a watercolor painting of the same line drawing).

**1**

1   Planning the sketch is the key to a successful result. Pick a viewpoint that will show the building at its best, with a light source that will give you the opportunity to describe any changes in the basic face of the structure. Remember the basic cube, and realize that you are not going to see the top of the building (unless a high vantage point is chosen). The lightest side then becomes the walkway, and the two main sides of the building the number two and the number three sides. The number two side will be the side that shows the most texture and detail; this is the side of which you would see the most.

2   Buildings are usually simple shapes, and a basic lighting plan is best to help create the illusion of reality. Remember the shading exercises in Chapter Two, and give some thought to how varied the light might be on even a smooth stucco surface. Notice how the lighting follows the plan described above. You see more of the number two side, which displays the most texture and detail.

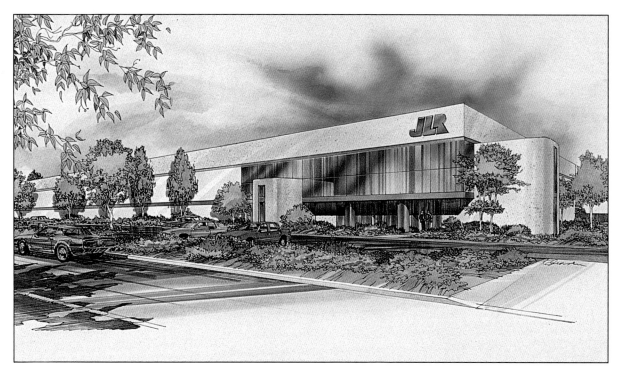

**2**

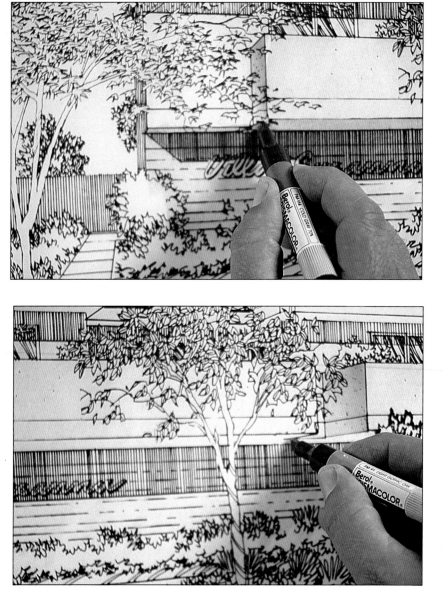

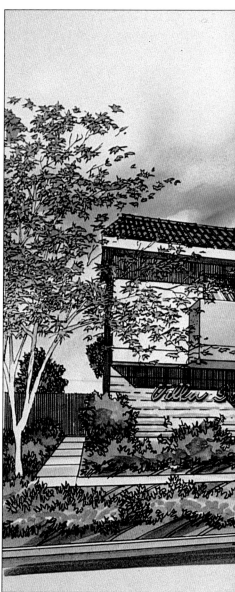

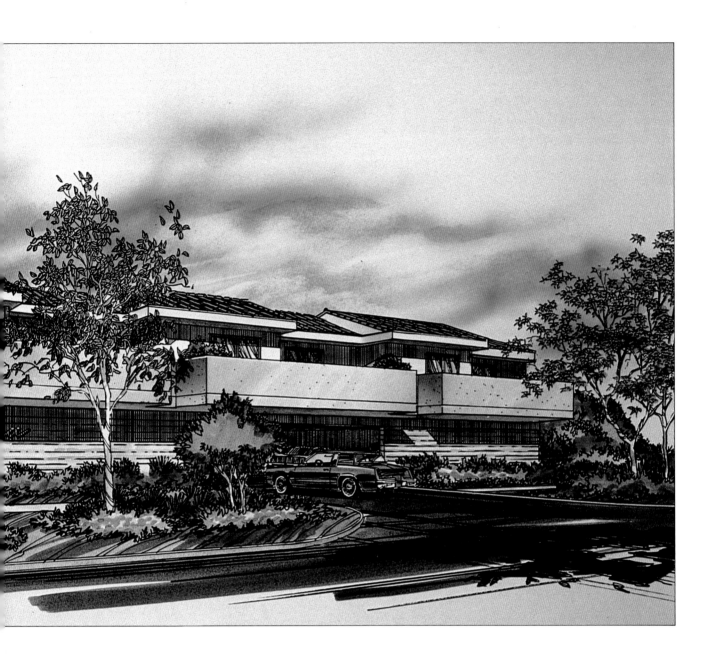

Work from light to dark, applying the overall color first, then add the tone and value to develop the necessary corner turns and contrast.

Texture is an important added dimension, and can be achieved easily with practice. Mask the area with Post-It notes, and use a toothbrush to lightly spatter the amount of texture desired. A small amount of tempera, the consistency of thick cream, works best.

Take the time to develop the exact result desired on a practice paper before you apply it to your final art. Develop the work habits necessary to establish different textures before you need them, then you will be ready to use these techniques when the appropriate situation arises.

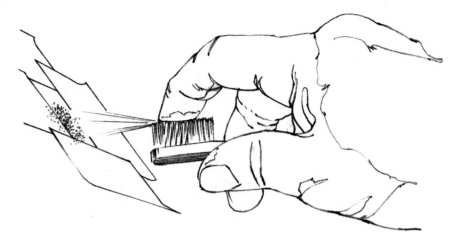

Some suggested basic textures for you to learn to render are stone, brick, wood siding, shingles, copper sheeting, cobblestone, flagstone, and hammered concrete. Search out scrap photos of these and other textures, and develop a technique you like for each. Keep notes; even make a notebook as a guide for how you did each texture.

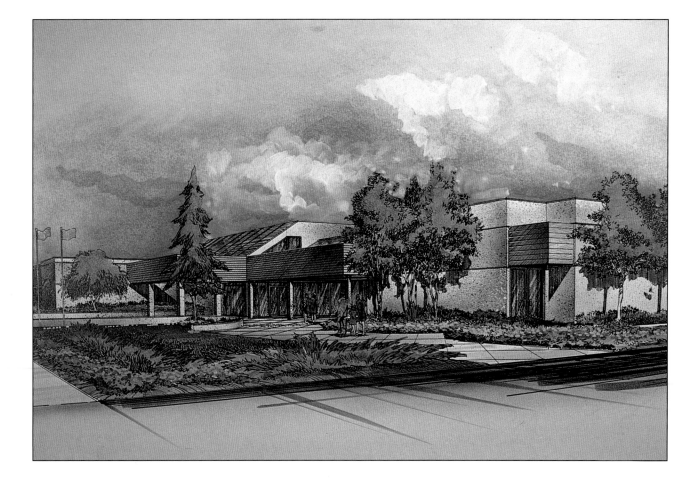

Windows offer an opportunity to show reflections, and add drama to a building. A simple, clear glass window will combine a reflection of the outside environment with a partial view of the inside. Reflective glass conceals the interior completely, and gives a much more accurate mirror of its surroundings. Use the window to add drama to your sketch, not to just mimic reality. Observe how windows appear in actual buildings, and compare them with the renderings you see in magazines.

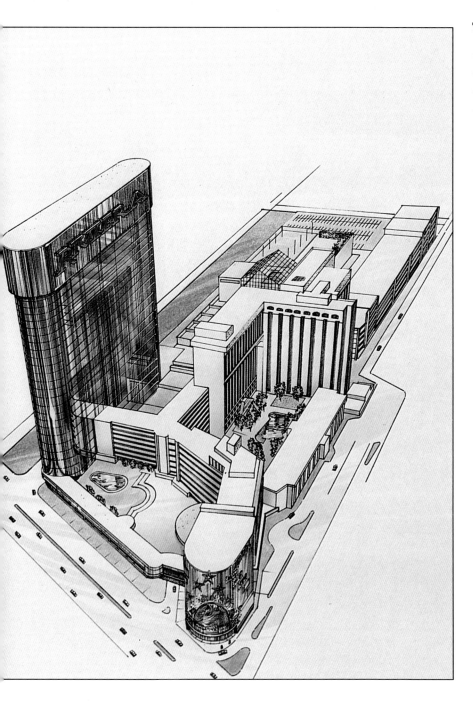

This high-vantage-point sketch was developed to show the new tower to be installed next to an existing complex of buildings. Notice how the shape of the structure is shown, emphasizing the "core," even though it is totally reflective glass. Very few plants show, and no sky, so the reflections had to provide all of the interest in the sketch, as well as describe the shape of the building.

Develop a scrap file of renderings, choose a window technique you like, and perfect it. There is no one correct way to depict windows. If the viewer accepts what is drawn as a window, it is successful.

1

1    Pavements, walkways, and other textured
     ground covers offer the opportunity to contrast
     and accent planting areas. Shade concrete
     walkways in light warm gray before using any
     green for the planted areas in the sketch, as it is
     difficult to avoid picking up the green with your
     gray marker. Many photographers achieve a
     dramatic look by watering down the surrounding
     pavement before they photograph a building.
     You may want to do the same in your rendering
     by using the techniques you have already
     learned for reflective surfaces.

2    Asphalt can be indicated with a dark warm gray,
     and cement is usually a light warm gray. You can
     blend in cool light blue tones as the paving
     recedes to add to the richness of the sketch and
     to create the illusion of depth.

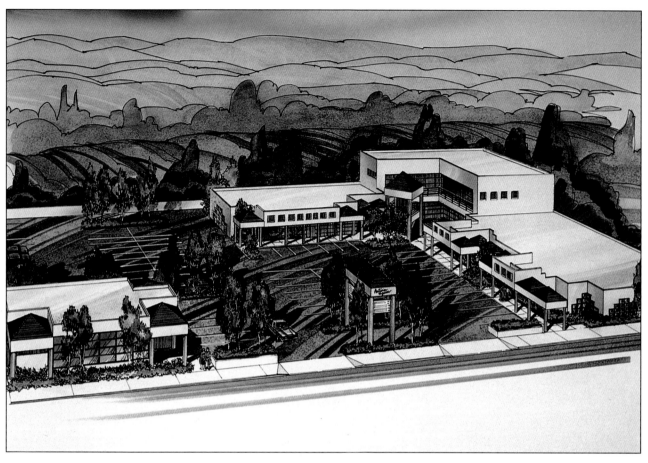

2

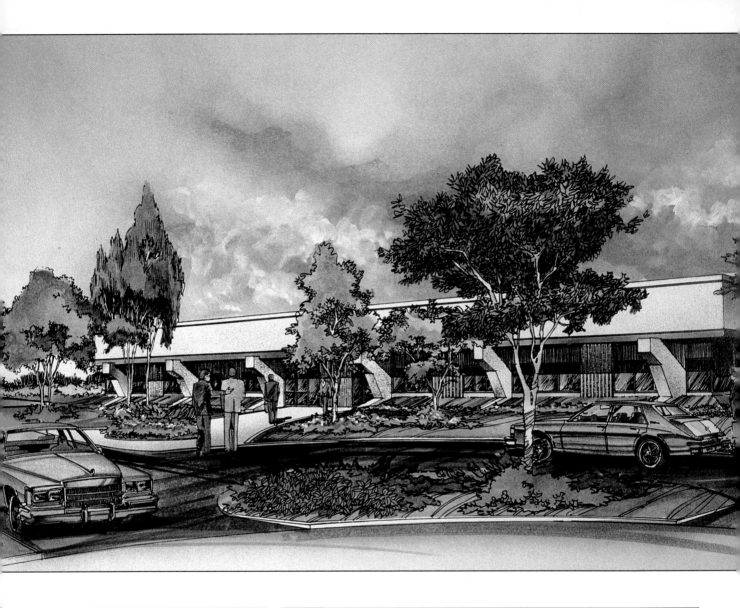

Landscaping is the organic complement to the strict geometry of buildings. Using trees and shrubbery to frame a building is a creative discipline that can be as complex as designing a building.

1

1  Plants in bright sunlight cast dark shadows, and the shadow area tends to have a blue tint, as it reflects the blue of the sky. Grass green works well as an overall grass color, with teal blue used to overlay and tone as the plants recede into the background. By saving the brightest colors of green for the foreground area and gradually working cooler blues into the green you can exaggerate the way color dims as it recedes.

2  Flowers and shrubs can be used to highlight the foreground or other areas of the building you wish to feature. Color in the bright flowers first, then work around the colored flowers with the green of the surrounding plants.

2

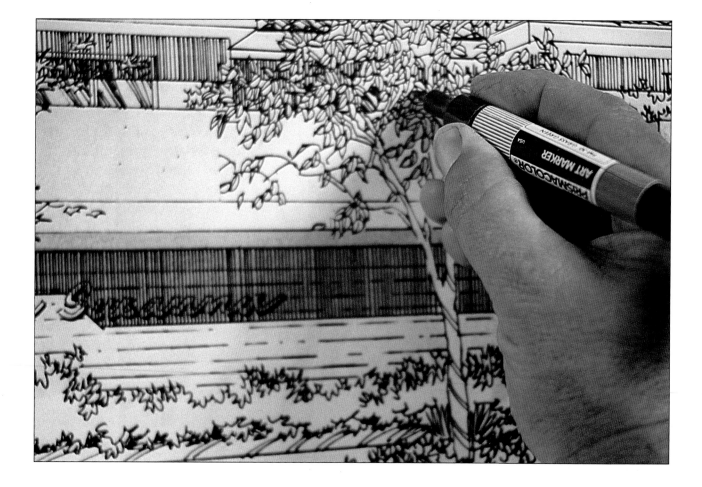

Plants and trees offer an organic counterpoint to the smooth massing of the building's shape and should be left uncolored until all of the basic structure in your sketch is shaded in.

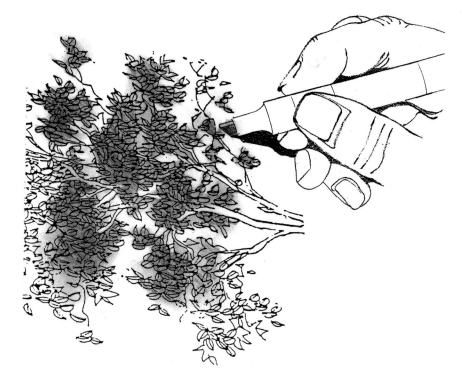

You can fill in foreground trees "leaf for leaf" with an overall tone (grass green no. PM-30), using the broad tip. Then fill in individual shadow leaves using the fine point, developing a pattern of shadow under the massing of leaves. Dark green no. PM-31 works well for this.

The green of the planted area can smear onto a white area very easily, so take care to rub with tissue only on parts of the drawing that are the same color. It is wise to practice on scrap before you try this on a finished rendering.

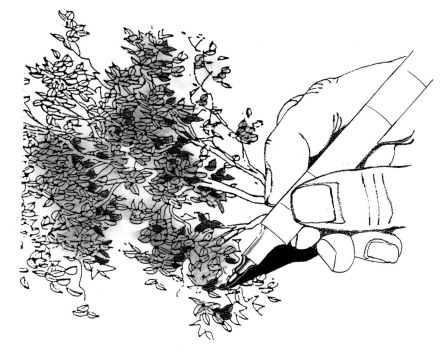

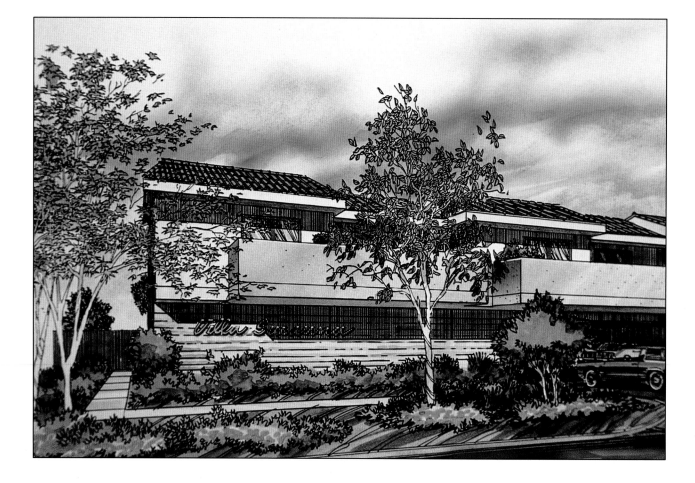

Notice how the tree provides a lacy overlay to the building. The pink of the stucco was established first, as though the tree was not there, then the tree was colored in. The general bunching of the leaves was shaded first with the broad nib of a no. PM-30 grass green marker; the sparser areas were finished next with the fine point. Once the leaves are given an overall green, use no. PM-31 dark green to provide the contrasting, darker leaves that appear under the lighter masses of leaves.

Most people think that tree trunks are brown, but unless you are surrounded by redwoods, you will find when observing the trees in your area that the more common color is a shade of warm gray. Observe, too, how trees catch the light on the tops of their leaf masses, while their underside is darker, and the trunks are darkened by the shade. The light and dark patterns on the trunk, as well as the correct shading of the leaves help to round out the tree, giving it a three-dimensional look.

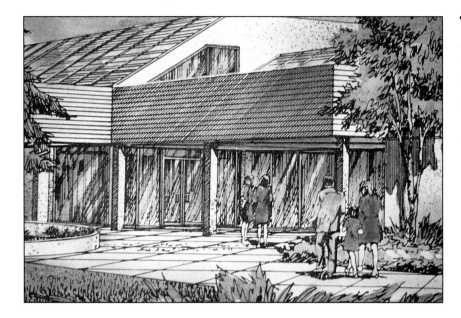

Complex shapes are best broken down to their simple components, then analyzed for the lighting plan that will best show their shape.

Planning shadows is very important to a successful drawing because the shadow defines the shape and creates an illusion of depth.

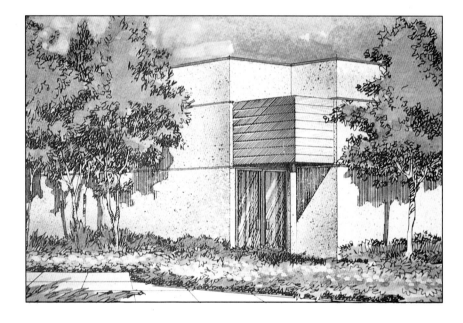

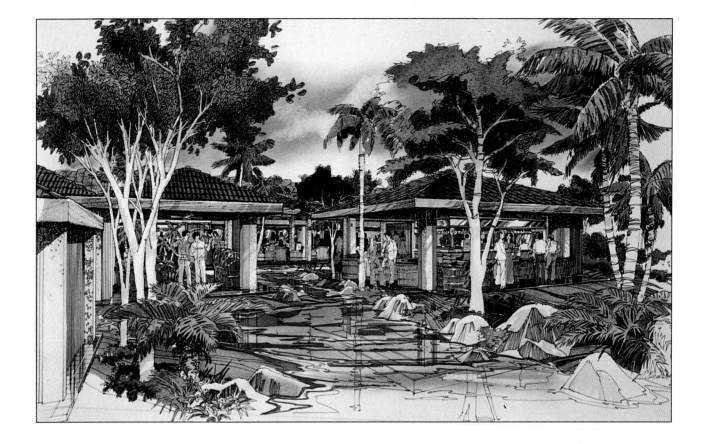

Water in a sketch, whether it is a small stream or an elaborate waterfall, offers an additional opportunity to add drama to your sketch. An understanding of mirrors in perspective is helpful for accuracy in your use of reflections in water.

Observe any body of water and see how the water acts as a distorted mirror, reflecting the blue of the sky and mixing it with whatever immediately surrounds it. Plan your reflections in the line drawing stage, creating a combination of mirror reflections and water ripples. The more placid the water, the more completely it will act as a mirror.

Water reflections can overpower a sketch, or so confuse the viewer that a clear understanding of the shapes and structures is lost. You can avoid this by remembering that you are in control of the sketch. You want the viewer to accept your depiction of water as such, but you are using it to enhance your sketch, not to dominate it.

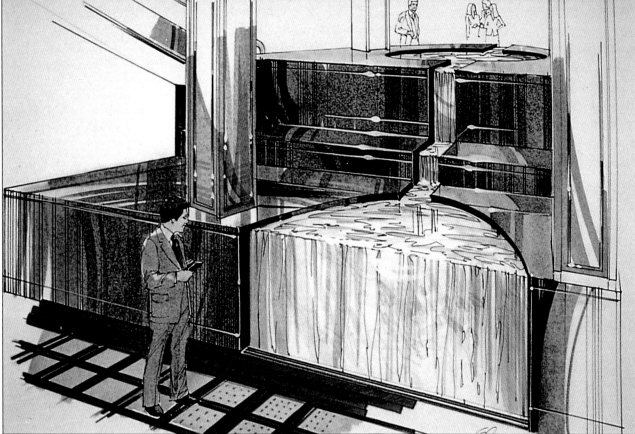

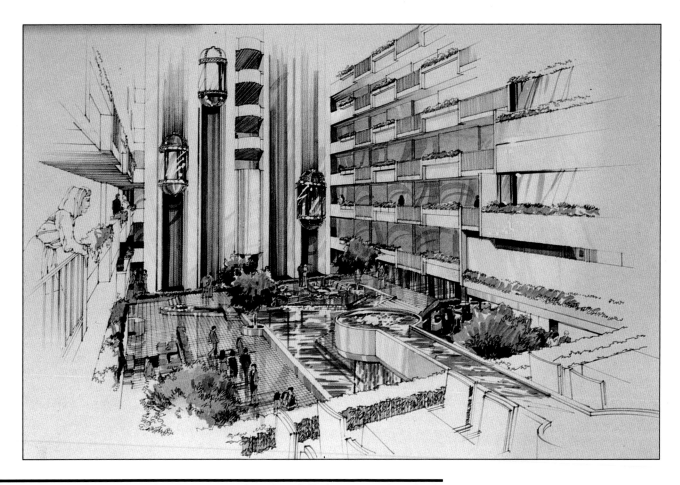

The rendering of exciting skies with markers may seem to be impossible, but skies are actually quite simple to draw—with practice. Photographs of clouds and how they are spaced in the sky are helpful reference materials. Collect photographs and develop a scrap file. Observe your surroundings and see what it is that makes up a cloudy sky. You will learn that clouds are not just white pillows, but are subtle gradations of tone.

Practice your sky rendering technique on blank sheets of vellum until you are comfortable with your ability. Start with the sky for the first few sketches so that you can discard the renderings if you are not happy with the results. This will allow you to start fresh without having wasted any time recoloring other areas—and will help you build confidence.

If your sky needs blending, try wiping the markered surface with alcohol. Lightly moisten a tissue with rubbing alcohol, then rub it gently on the drawing's surface to blend the colors. You can also blend with a 10 percent cool gray. As you become more skillful, you may want to try some more exotic accents. For example, once you are comfortable with sketching a simple sky, such as the one shown here, try using different colors to finish and blend. Lavender, lilac, and light violet all add accents that might be present at twilight or at the beginning of sunset; use them at the lower portion of your sky. Remember to experiment, and keep scrap samples of skies that you like to serve as reference.

Blending colors is simple. By applying the tissue rubbing technique you learned in Chapter One and using colors that work together, you can achieve the results you want. Practice first, and use a separate sheet of vellum to try out combinations before using them on your final art. Airbrush marker can add a final touch to your sky, but care should be taken to avoid overworking it.

These are the basic techniques for architectural renderings. Markers offer the beginning illustrator an ideal entry into the world of architectural illustration. Once you have the ability to draw a building in perspective, you can learn to draw landscaping. Then you will have the skill to create finished line art to copy onto vellum and color with markers. The key to success is practice—you can do almost anything with markers if you take the time to refine your skills.

# SKETCHING INTERIORS

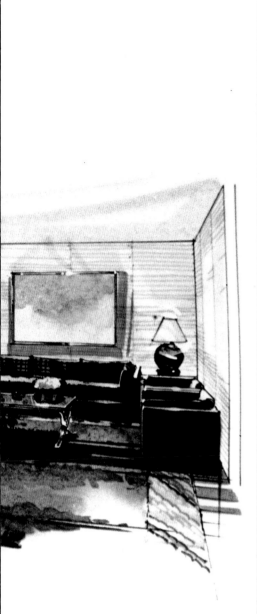

Architectural illustration, by definition, is the illustration of buildings. It is rare, however, to find an artist who can draw the interiors of buildings as well as their exteriors. There is a simple reason for this: The skills required to do a high-quality interior sketch take longer to learn, and include a knowledge of furniture styles and a particular color sense. Interior sketches are commissioned for a variety of purposes, including advertising new homes, hotels, restaurants, and offices. The client is usually the interior designer, who has, in most cases, selected the furniture, designed the floor plan, and chosen the colors. The designer will expect the rendering to not only show the shape of the room accurately, but also to capture the atmosphere created by the chosen colors.

Major interior sketches, such as renderings of hotel lobbies, ballrooms, and restaurants, should also have a dramatic center of attention and give the impression the client wants to create in his new establishment. Twelve or more renderings may be commissioned for a hotel project, with fees in excess of $10,000. This may seem like a lot, but the overall project may be worth in excess of $20 million, and most of those who approve the project will judge it on the basis of the quality and accuracy of the sketches.

You do not start a career in illustrating interiors by doing a hotel package, but rather by developing the ability to do simple rooms first. In this chapter you will learn to build the room step by step and give it the necessary ingredient of atmosphere.

Light and shadows can become very complicated in an interior study. It is best to start with a plan before you begin to color.

Planning the lighting for the sketch includes first determining the light level. Begin with a well-lit room with off-white walls. This lighting scheme requires a very light hand and a lot of paper white (the actual color of untouched paper). Paper white is the most valuable tool you have, if you use it wisely. Once you have colored it, you cannot regain paper white. Plan your sketch with the paper as the high-key, or whitest areas. Leave as much paper white as you can, working up to it, keeping in mind that you can always add tone, but cannot add untouched paper without splicing, a last resort.

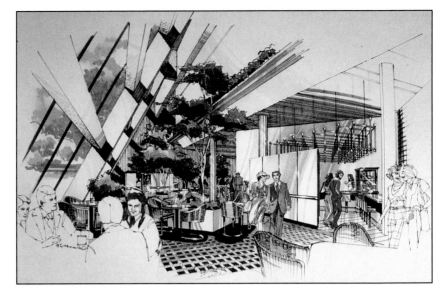

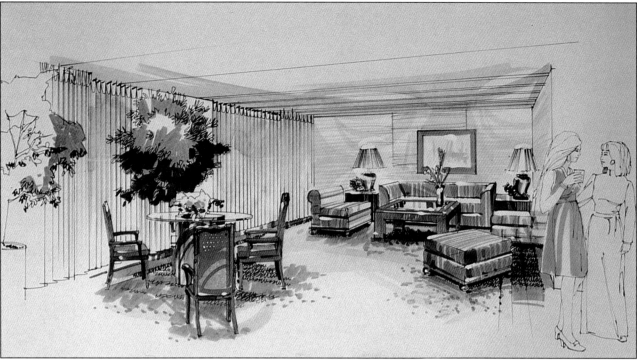

**1**

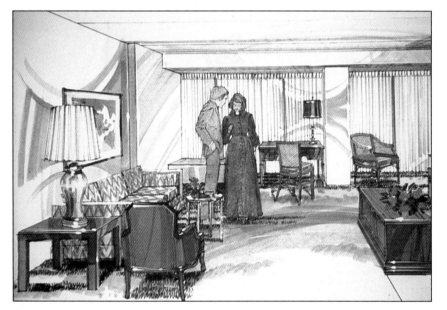

**2**

1 Because the ceilings in most rooms are white, this will be true in most of your sketches. Recessed fluorescent lights are also usually white. The difficulty in showing the room in a high-key scheme is compounded by the need for a range of values. Even though the ceiling will be white in color, it will show the least amount of surface detail and texture. In addition, most of your light sources will be shining down into the room, leaving the ceiling in relative shadow. These factors make the ceiling the number three side of your basic cube lighting plan; that is, the darkest side. The lights in the ceiling are best left paper white, or tempera white, for emphasis.

2 The walls are lit by lamps or ceiling fixtures, and paper white again can be used for the lightest white. Walls do not receive a smooth, even light. Look around you and observe how a wall can change value radically as light reaches it from a lamp and is shaped by the shadow of the lampshade. Use these realities as a guide, not a dictator. You control your sketch. Use the lighting to help the picture, logically letting the viewer see how the light might fall.

Interiors are a collection of simple shapes in a complex sketch, done one step at a time. Establish the value pattern of the walls first, then the ceiling, and, finally, the floor.

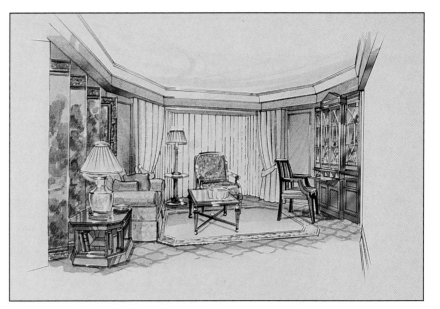

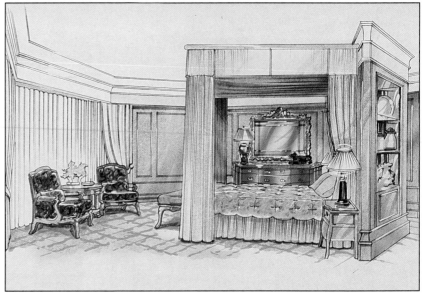

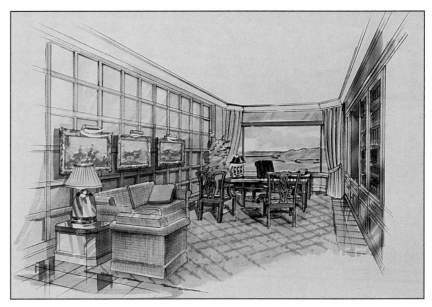

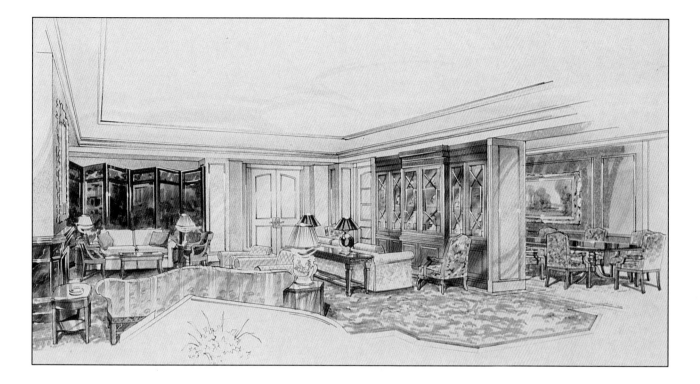

Matching colors and textures is simply a matter of taking the color chart you have made, comparing it with a sample, and picking the closest marker color. Textures can be matched by establishing the color first, then using Prismacolor pencils to indicate the texture. Test your best guess on scrap first, then apply it to your final drawing. Remember that you only see details up close; they fade as they recede into the background or move into shadow.

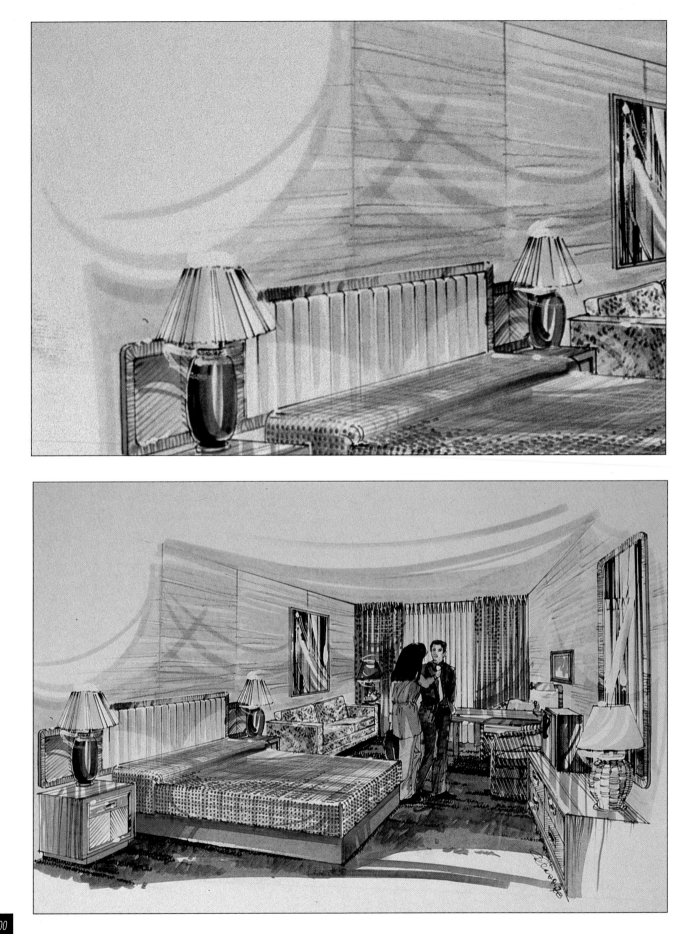

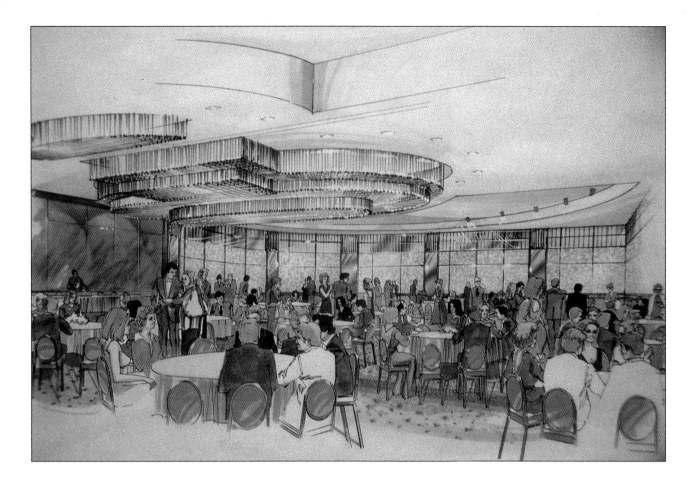

Commercial interiors are generally larger than residential interiors, but the same simple lighting plan still applies. Walls are established first, then ceilings, and finally the carpets or hard-surface flooring.

Planning shadows to show depth is important. To emphasize the depth, it is best not to render objects present in shadow areas in great detail. Observe the sketch of the ballroom that is shown here. The tables are each shadowed with a different light source to expand the visible carpet area and increase the perceived space. People used in the sketch also help to show space, and emphasize the overall size of larger spaces.

1-2 Using strokes to show the light source is one of the keys to a successful interior rendering, especially of a large space. You will see that making the lighting work for the sketch is the key to creating a vibrant space.

3 Finishes can vary from smooth metal to nubby fabrics, and you need to be able to convey the difference. Fabrics do not turn sharp corners, nor do they hold a ruler-straight edge. By showing the highly polished furniture consistently crisp and glossy, and upholstered goods softer and less even, you establish a believable range of surface textures. Sharp edge lines should be avoided on upholstered furniture; a soft transition from the top to the front of the cushion helps to give the look of a pliable surface.

4 The polished wood, mirrors, and brass lamps offer a marked contrast to the soft carpet. Liberties can be taken with matching samples provided by the designer, such as enlarging the pattern slightly to be able to more accurately depict it, as was done with the bedspread in this sketch. This helps to show the patterns that might otherwise be lost if shown in actual scale.

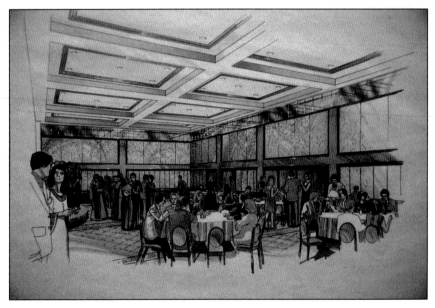

1

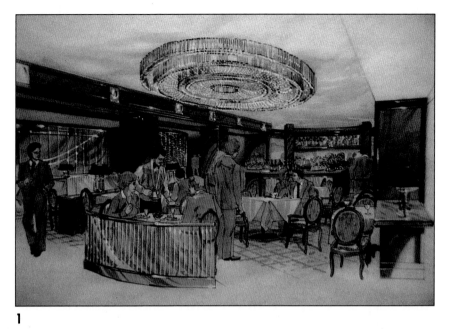

2

3

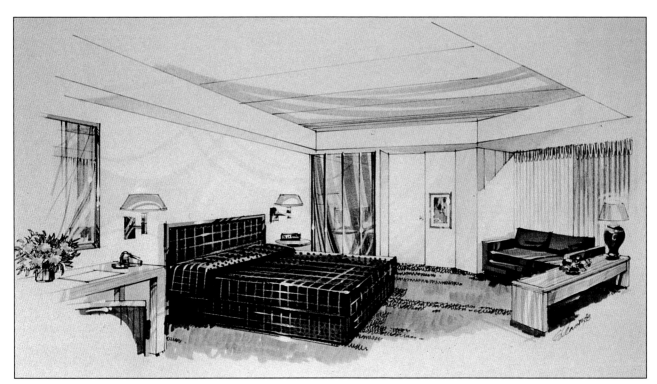

4

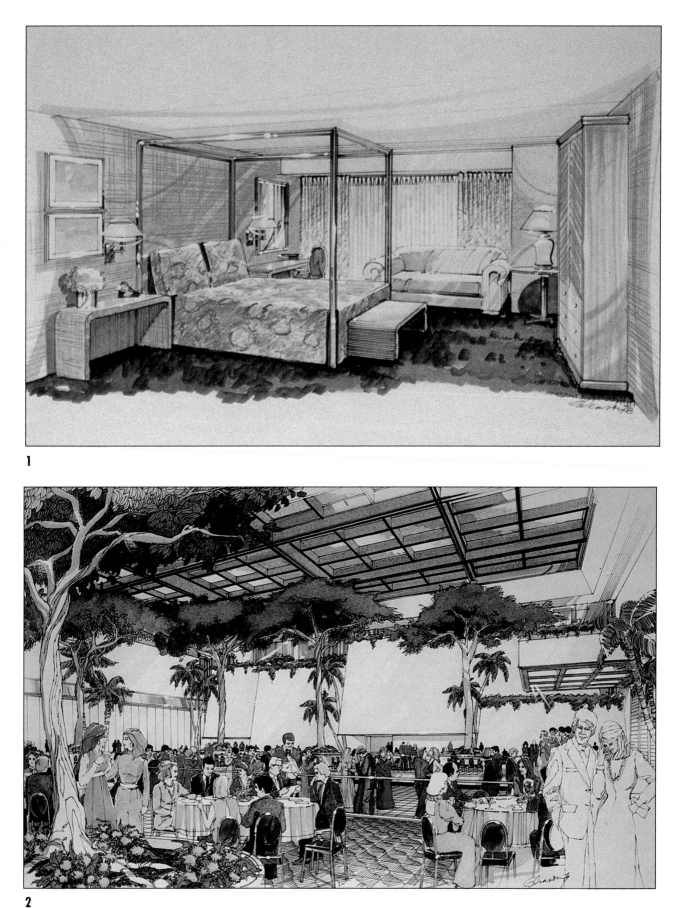

1

2

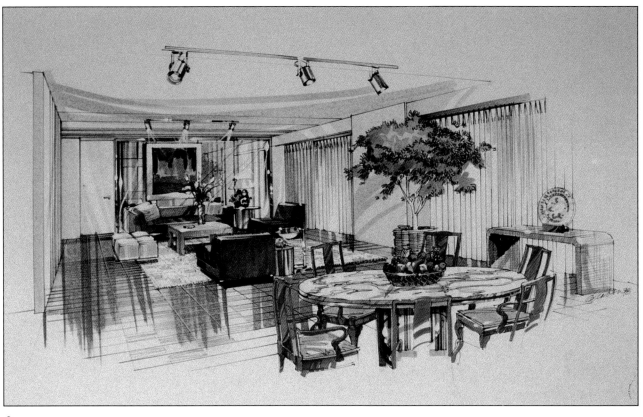

**3**

1 Establishing a consistent pattern is the key to indicating wallpaper in perspective. This wallpaper has a hand-woven character, so the horizontal weave was laid in by hand; however, the vertical seams were drawn more carefully, with a straight edge.

2 Carpet patterns can be very important to the look of a room. All patterns have a repeat and can be plotted in perspective. Obtain a photo of the pattern you are using as it appears installed. Observe the repeat and the way the pattern becomes an overall texture. Is the pattern diagonal? Does it seem geometric? What is the overall background color? These are the basic observations to make before drawing in the pattern. You may wish to try drawing the pattern on one or two overlays of tissue, experimenting with the pattern indication you think is best before actually coloring your final art.

Establish your overall carpet pattern before coloring in the furniture and people. You may wish to lay in the pattern, then wait long enough for the marker to set before you shade and add shadows. Marker will set over a very short period of time (a minute or two) and be more resistant to smearing when you lay a dark tone over it, as when shading or laying in a shadow. Remember that the pattern shows in detail only in the foreground and becomes less distinct as it recedes into the background.

3 Modern upholstery is a contrast of overstuffed cushions and crisp outlines. The challenge is to draw the piece correctly, in the right pliability and color. Establish the overall color first. Observe photographs of the actual piece and notice how the light brings out its shape and softness and how any tufting and welting, while soft, is still held to a regular repeat.

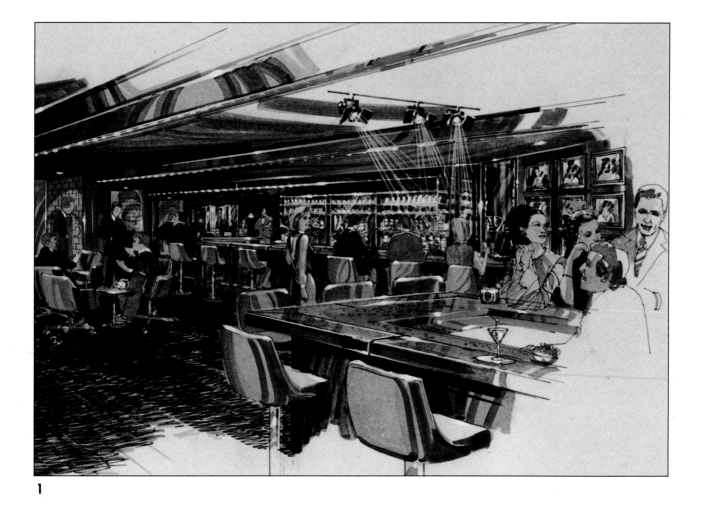

1

1  Accent lighting can enhance and add drama to any room, but in order for such lighting to show well it needs to be seen in a darker room. This means your rendering should show less paper white and more applied marker. You may even need to add value to the back of the sketch, working either with the color used on the front or a dark cold (or warm) gray. The sketch shown here was especially difficult to draw, as two layers of dark green marker were applied to the front of the sketch and additional dark gray (even black) was applied to the back of the vellum before the sketch was finished and dry-mounted.

2  Spotlights and track lighting, as you can see, are best shown by the light they inject into a sketch and the shadow they cast. Neon is also shown by its effect, and is best drawn in color. Marker airbrush is applied to the entire neon area, colored to show the glow emitted by the light.

The challenge of doing an interior sketch is certainly a big one, but not impossible. Take the time to practice each step as outlined in this book, and you will develop the skills necessary to do a good job.

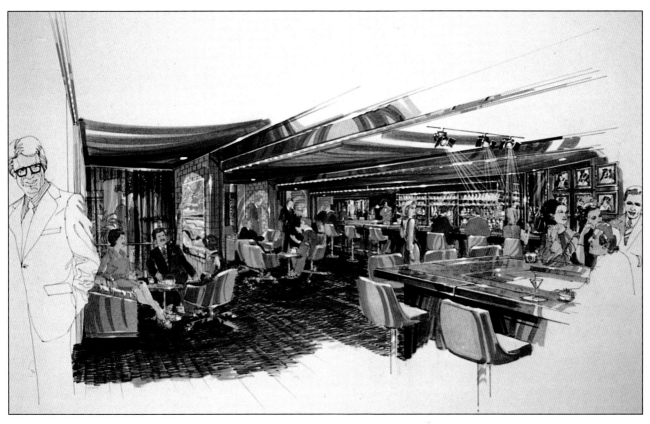

2

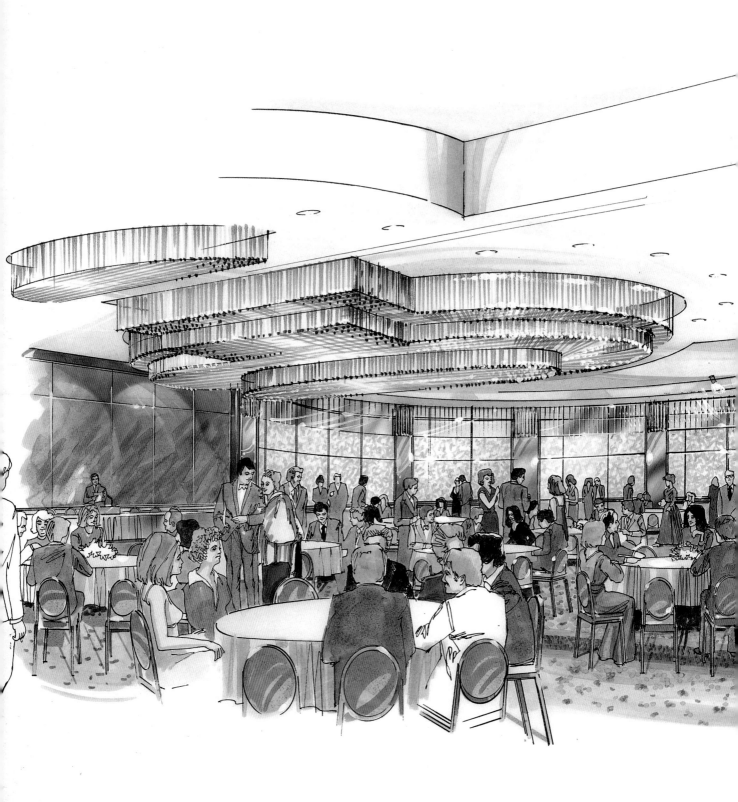

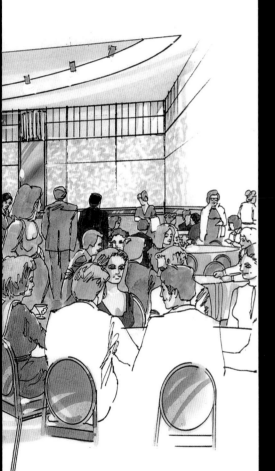

# SKETCHING FURNITURE

Illustrating furniture within an interior perspective offers several challenges. The principles outlined for product sketching in Chapter Three are applicable here as well. In an interior perspective, however, the overall atmosphere of the room is important as well.

Furniture falls into two main categories: *Upholstered* (sofas, chairs, and such) and *casegoods* (tables, cabinets, and other wood pieces). Additional elements found within a room are: accessories, plants, and works of art, such as paintings or sculpture. Furniture appears in the following four main types of interior renderings: *residential* (Living room/den, dining area, and bedroom); *office* (reception area, conference room, and desk/workspace); *restaurant/nightclub* (lounge, dining area, and booth/settee); and *banquet/convention hall* (pre-function lounge, dining area, and theater/conference rooms).

Notice how the first and second categories of furniture types are similar in all four categories of interiors, and each type of interior has a third, unique furniture type not seen in the other three. By subdividing your subjects into categories, you can see how learning to do a certain kind of furniture prepares you for more than one type of rendering.

The sketches on these pages show just how detailed the typical residential and commercial interior can be. The basic lighting plans established in the previous chapter are still at work in each of these drawings, but now you must take into account how your rendering of both light and texture will affect each and every aspect of the room.

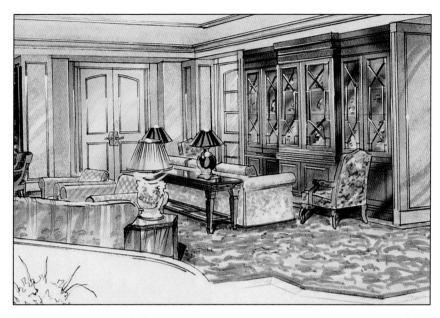

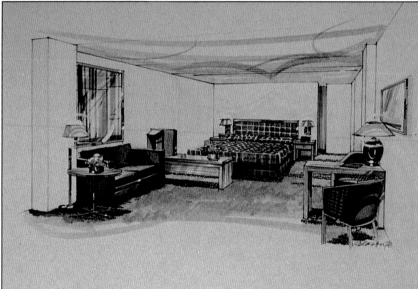

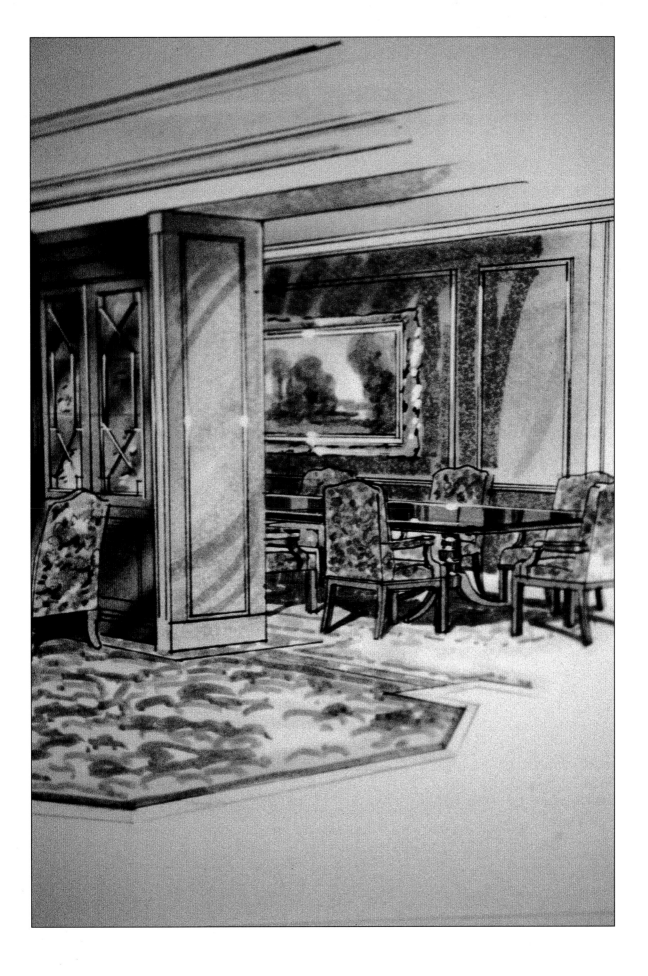

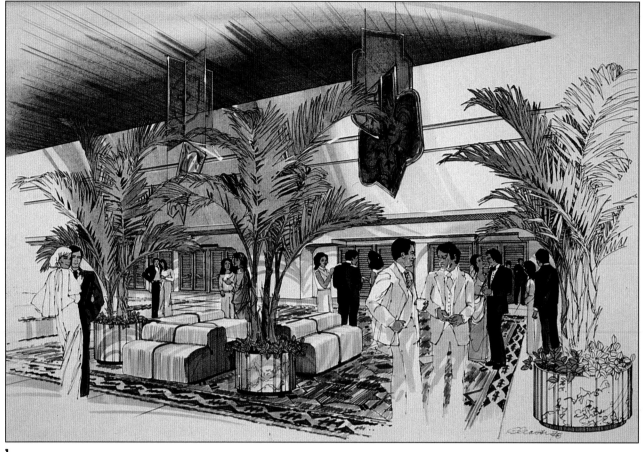

1

1 Upholstered goods are difficult to render because they do not have hard, sharp corners, yet they must have a number one, two, and three side. The key to success is to carefully examine your reference photographs of the piece and notice how much fullness the rounded corners have. Remember the cylinder "core"? Use it to show the transition from top to side; the fatter the "core," the fuller the corner will appear. Also notice how the fabric shows seams and wrinkles. In general, these are arranged to show a characteristic pattern. Button tufting, channeling, and welting also have their own unique appearance in a sketch.

2 When you select your viewpoint for a rendering, take into consideration the furniture as well as the architecture. Sofas and beds look best if seen directly, rather than from above. Dining tables, on the other hand, can be a nice foreground element.

3 Plants are an organic counterpoint to the hard-edged surfaces in the room and help to fill in space that is too empty and uninteresting. Be sure to have good scrap art on file for plants, and draw specific rather than generic forms.

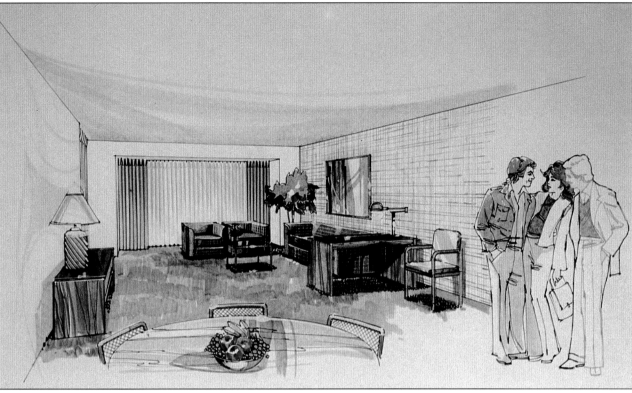

**2**

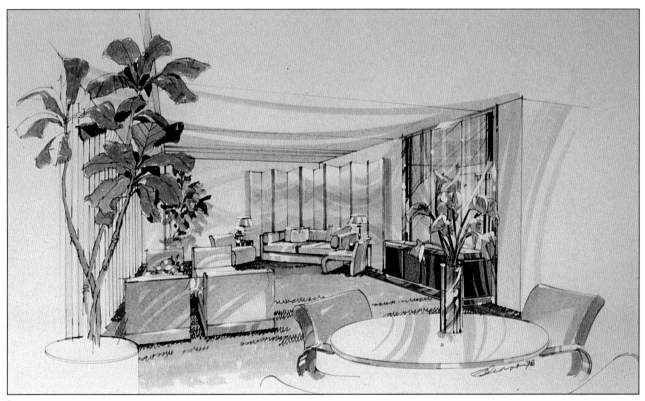

**3**

Good interior photographers are very adept at dramatic lighting and accessorizing. Develop the habit of saving good photographs, and take note of how the photographer dramatized the room. Copy what you feel is successful, but remember that if the sketch is of your own creation, you have much more freedom in what you draw.

The overall lighting plan of the room should dictate the way each piece in the room is shown. If there are several pieces in the room made of the same color of wood, color them at the same time. Select the correct color of marker, and then work the number one, two, and three sides of all the wood furniture in turn. Once you have established the overall shading of the wood, select a Prismacolor pencil that matches the dark of the wood grain and use it to indicate the grain on each of the number two sides of the wood. Keep a sample of the wood grain in front of you for reference, and imitate it as best you can.

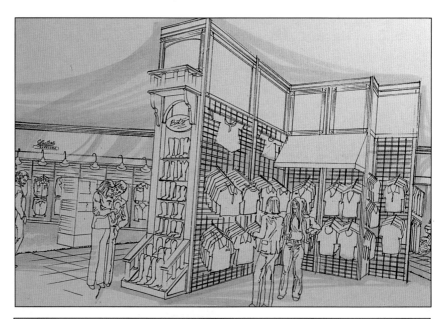

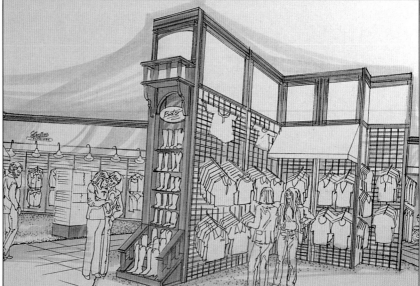

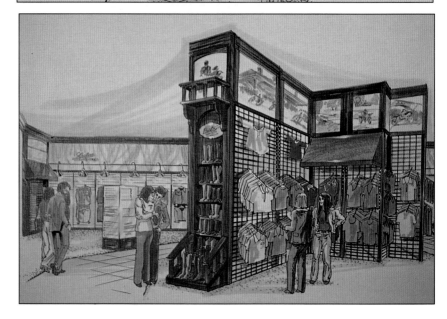

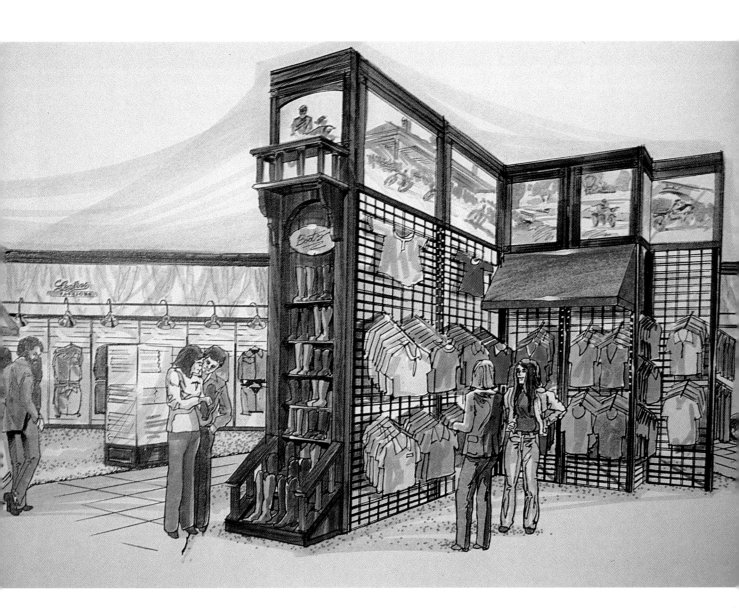

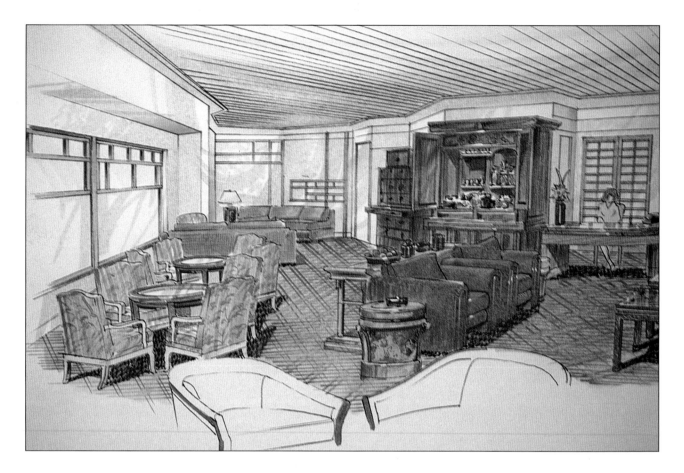

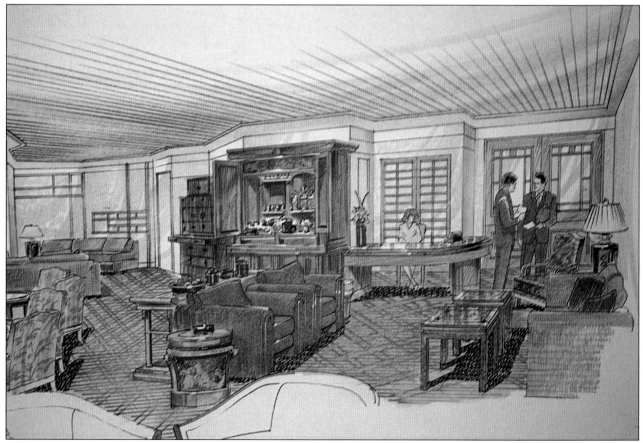

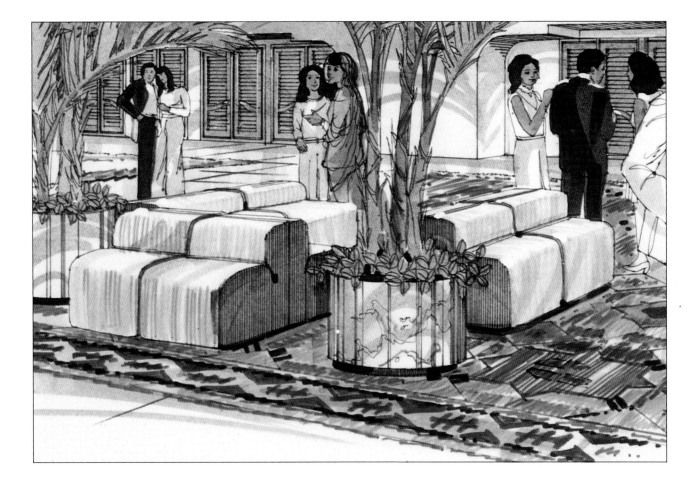

Matching the color to the surface finish can be very important to your sketch. The designer has spent time establishing the scheme, so be sure you are given a finish sample of each piece you are drawing. Is it matte or glossy in finish? Is the wood grain straight or very irregular? Learn to analyze before you draw, and ask yourself these and any other questions that would help you to define what you are going to color.

Colors and patterns in upholstery offer a unique challenge, as you must correctly indicate both the chosen fabric and the shape of the furniture.

This series of drawings illustrates the typical procedure used in coloring an interior. First, select the overall correct marker color, using the chart you have made with your paper. Establish the number one, two, and three sides; *then* indicate the pattern, using the appropriate Prismacolor pencils and the fine tip on the marker. Usually only one marker is just the right color, so you must extend the value range of that marker. Rub with tissue for the lightest, or the number one side; lay in the number two and three sides full strength; and then add another coat to the number three side. You can further darken the color by working on the back of the vellum with the same marker, or by using a marker that is still darker, but close in color.

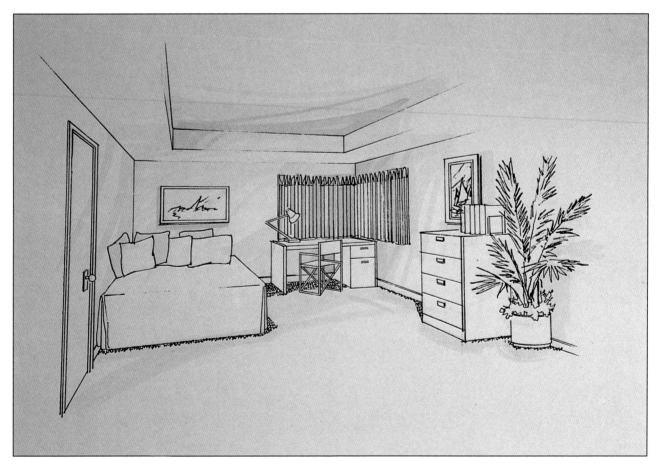

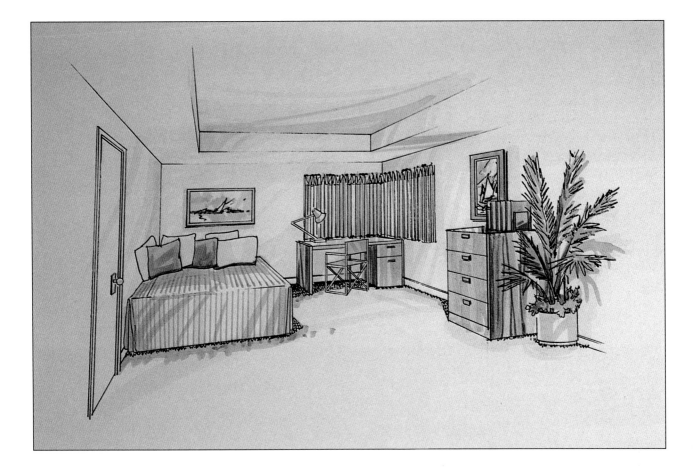

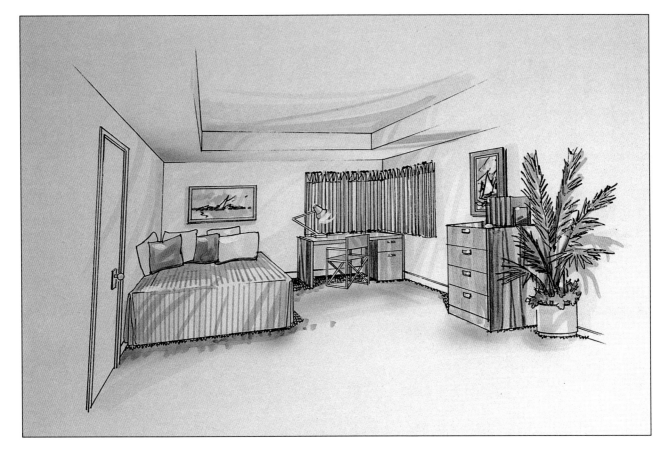

Take note of any mirrored or reflective surfaces within the room and and make sure that they, too, follow the logical pattern created by your lighting plan. In these sketches, observe how the colors of the furniture are approrpiately reflected in the mirror, the television screen, and the chrome highlights of the console. These are the details that add both realism and atmosphere to your sketch.

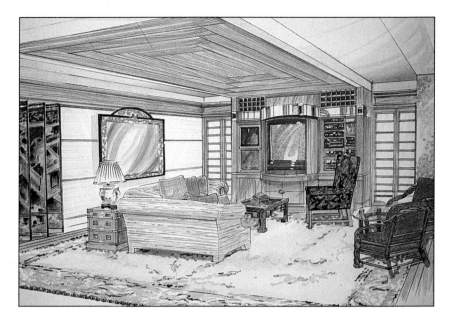

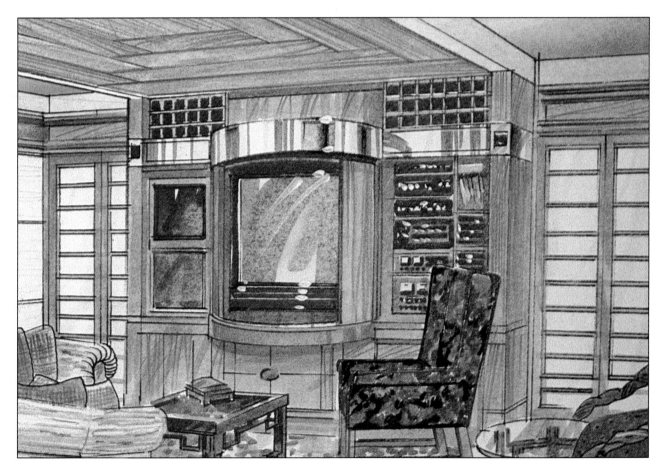

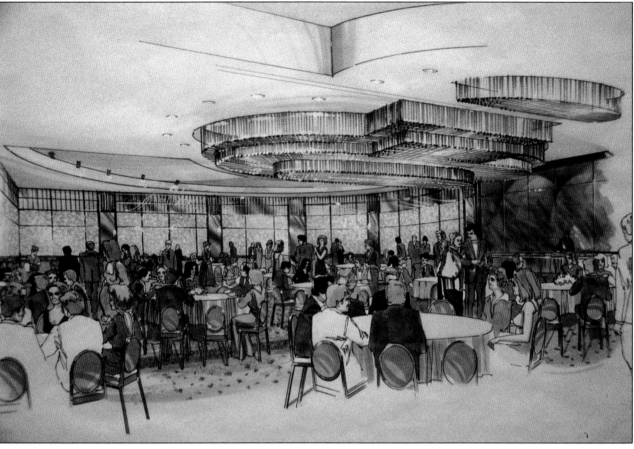

**1**

1   Brass is the most common accent metal in residential and commercial interiors, and is quite different from chrome, as is shown by the large brass-plated wall in the interior shown above. Yellow ochre is a good overall color for brass, with brighter yellow accents used for highlights. Burnt umber makes a good darker color, and black can be used to provide the abrupt dark bands that show reflective metal. Highlights can be white tempera, with some yellow added for a more realistic look.

Once the wood has been finished for individual pieces of furniture, color in any decorative trim, hardware, and other details. These details should follow the same logic of the number one, two, and three sides as the pieces of furniture upon which they appear.

**2**

1  Simplifying complex pieces is the key to success in large and more complicated illustrations. Look for the simple forms in complex shapes, then shade them as you have learned.

2  Look for the light source, then use it as a guide to shading the furniture. Remember that unlike exterior renderings, which have only the sun as the light source, an interior may have many light sources. There should be a reason for each light source, and it should affect at least the furniture immediately around it.

3  Basic shapes cast simple shadows, so as you look for these shapes within complex pieces, you will also be getting hints on casting shadows about the interior. Shadows offer the opportunity to increase the value range of a sketch, describe the shape and height of the article, and provide a solid base for your sketch.

Accurate depiction of selected furniture is the result of careful attention to reference material, but you also need to make your sketch a success. Compose your furniture depiction as you would any other aspect of your sketch: Create a center of interest and treat the balance of the objects in the room accurately, but not with as much importance.

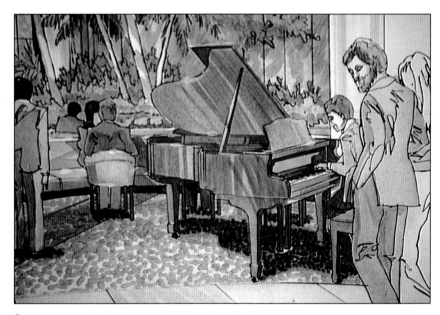

1

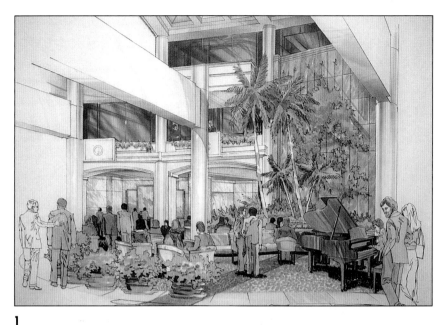

2

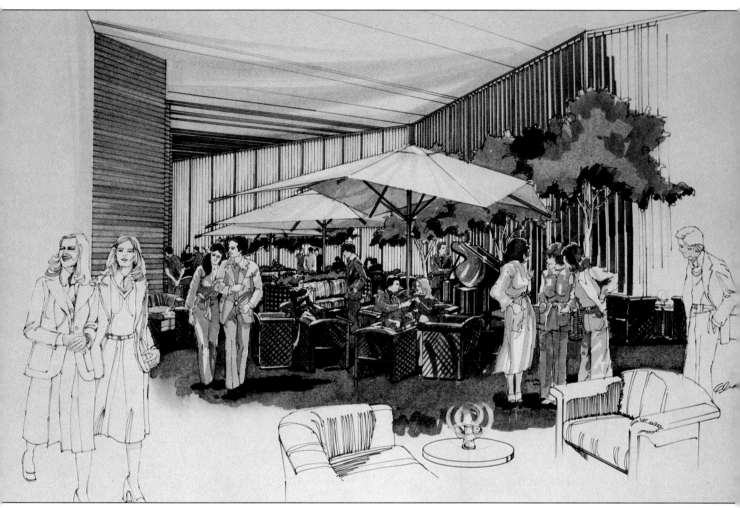

3

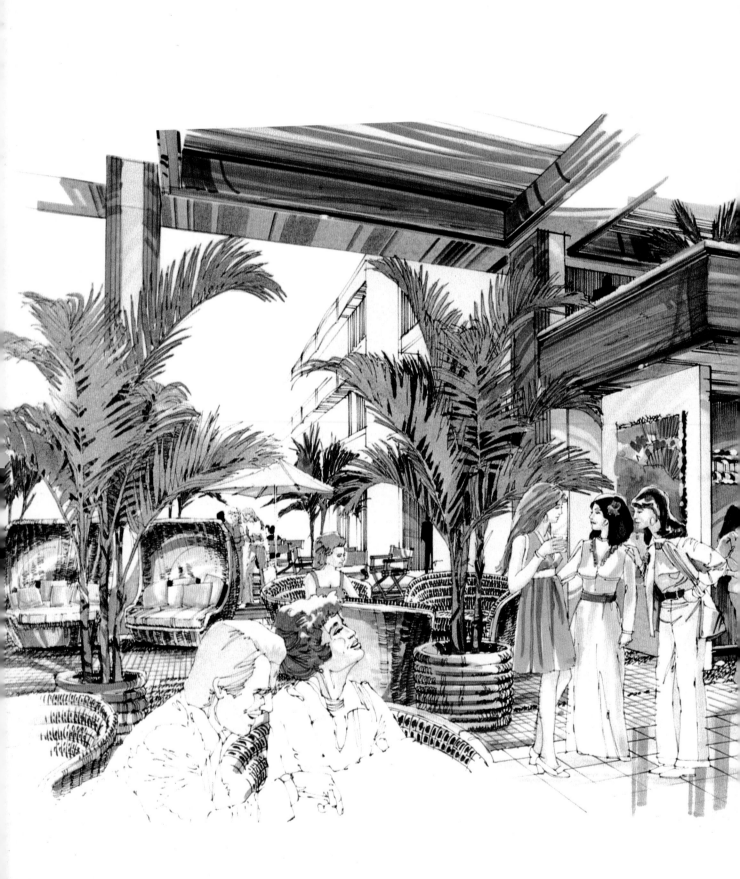

# SKETCHING PEOPLE

Figure indication plays a vital role in many aspects of rendering. Including people in a sketch can help to establish scale and atmosphere, and can also focus attention on the center of interest in the sketch. As much as people can aid your sketch, however, the first thing that a viewer will notice in a sketch will be a poorly or inappropriately drawn person.

Where is the setting of your drawing? Is it a resort, or a more businesslike setting, with offices and conference facilities. The client should provide this information, as he or she has probably done a great deal of research on the project before presenting it to the designer or illustrator. You should have a clear idea of the activities and types of people in the environment of your drawing.

Here are some of the details you might want to consider: Will there be a definite age group using the facility (retirement home, day care center, singles bar, and so forth)? What is the climate and time of year you are depicting in your sketch? Should your subjects be wearing short-sleeved shirts, sweaters, coats, shorts, or swimsuits? Is this an environment with a dress code? If so, don't draw figures wearing T-shirts or shorts, and draw the men wearing ties.

Notice the figures in the accompanying illustrations.
The people in each sketch seem to belong; they do
not overpower the drawing. They are not dressed to
call attention to themselves, and they seem to be
doing something, going somewhere, or looking at
something in the room. They enhance the sketch
without drawing attention away from the main
subject.

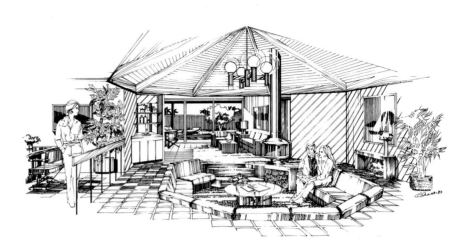

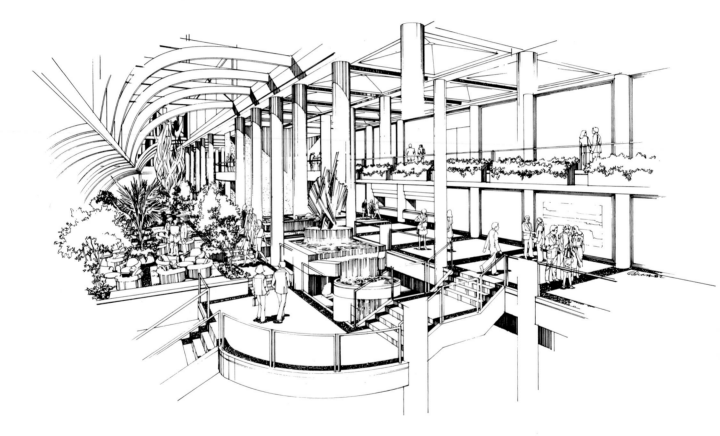

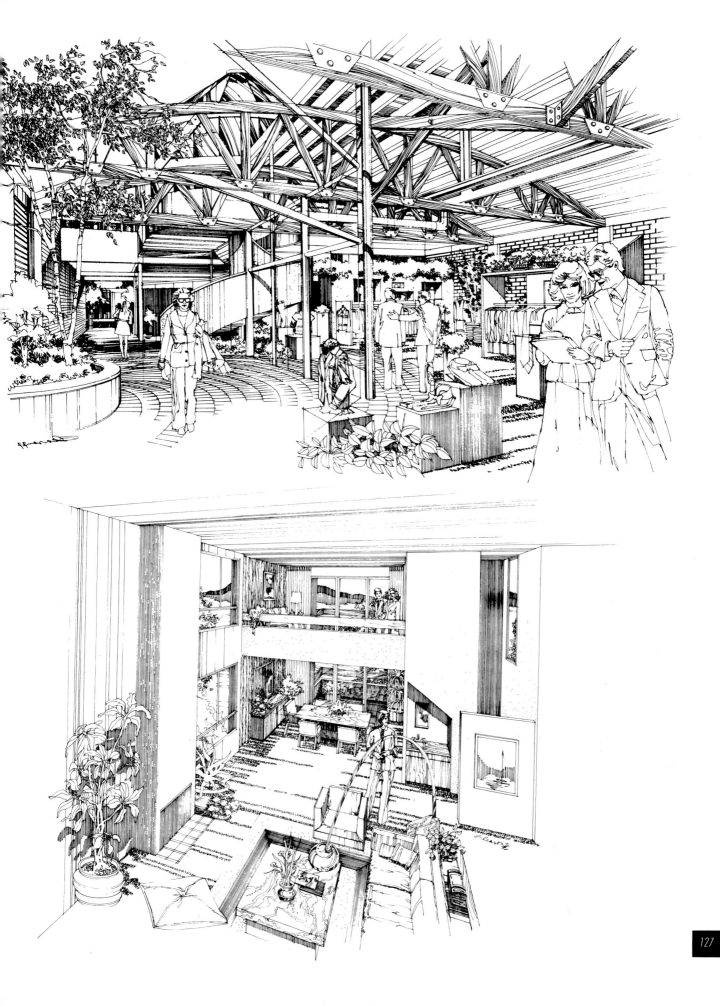

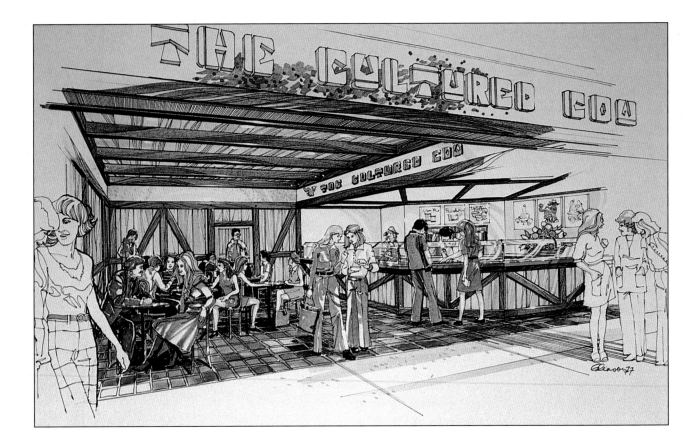

Develop a tracing file of people posed in normal positions and wearing up-to-date clothing. Sears, J.C. Penny, and Speigel all publish clothing catalogs regularly, and enlarged copies of appropriate figures can be traced from these catalogs to keep your files current. The most difficult figures to find are those walking away from you, yet these can really make a sketch as they lead the eye into the room.

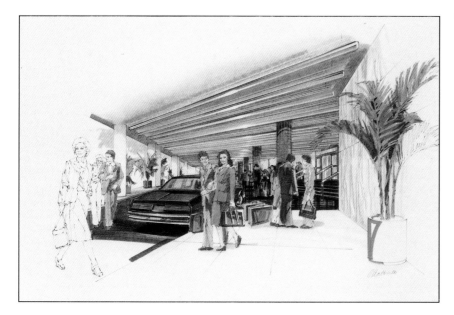

Observe how effective a foreground figure can be, especially if color is left off, allowing the eye to focus on the room. Leading the viewer into the picture by facing the largest figures into it is not only good composition, it draws the eye to the center of the sketch and the real subject you are depicting.

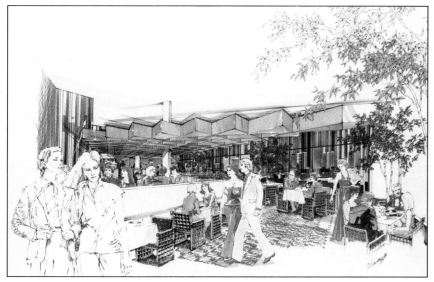

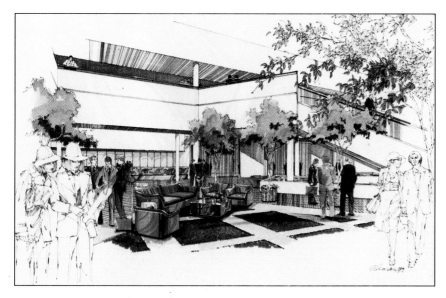

Classes in life drawing are available in most local colleges, and these can help you to become more adept at drawing the human form. Trace the face first, and learn how to indicate the eyes, nose, and mouth with an economy of line.

Markers are simple to use for indicating flesh tones, depending on the racial mix in your sketch. Basic Caucasian skin tones are laid in with a flesh marker, and shaded with cedar. Darker tones can be established to meet your needs and to give added social and visual balance to the sketch.

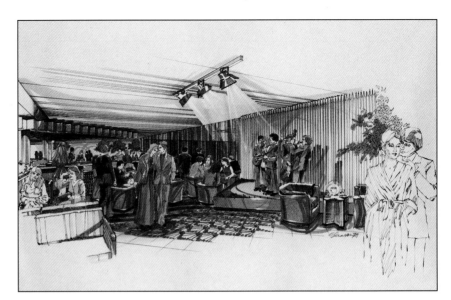

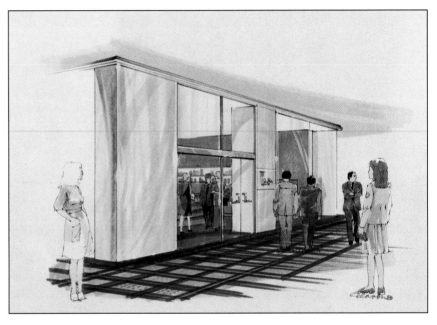

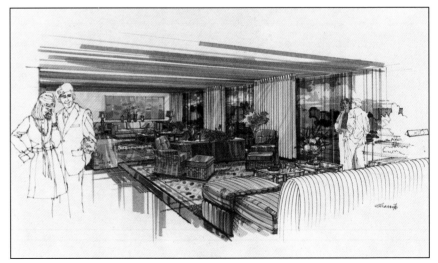

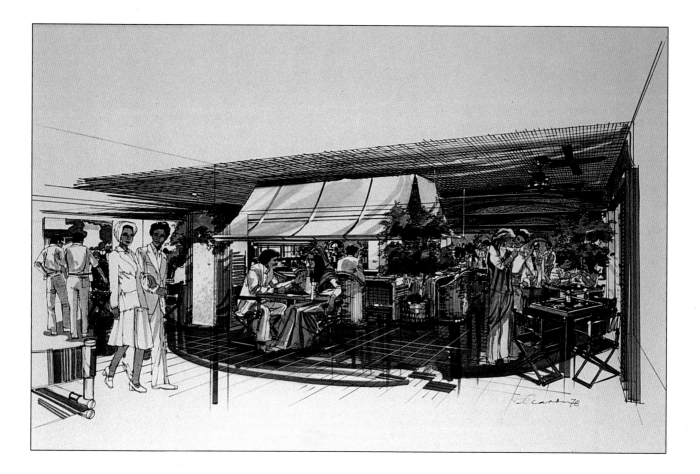

This sketch was part of a project in Bangladesh. The client requested that people dressed according to local customs be shown, along with tourists from other areas. The clothing and mix of people in a sketch can create a mood and show the sort of environment that surrounds the room. Show men and women in suits, and you create a businesslike atmosphere in your sketch.

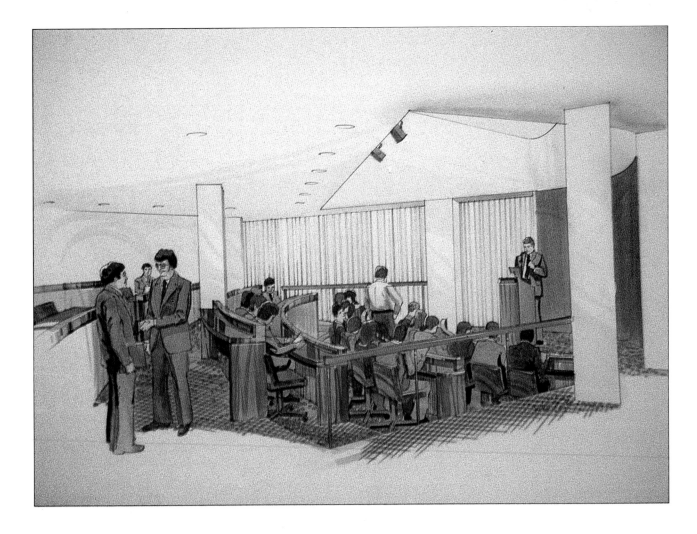

Show people in casual attire, and a resort is the impression established. Brightly colored clothing also gives a festive flavor to the sketch. Color the clothing last, after the rest of the interior is done, to see what is needed to balance out the sketch. Avoid colors that are too bright or radical, as they will make the figure the most important part of the sketch.

Once the clothing is colored, folds and shadows are laid in to fill out and add dimension to the figures. Leave a little paper white on top of the shoulders of the people closest to the viewer, and lay darker tones on those in the back.

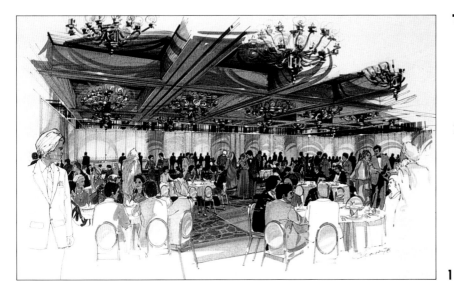

1 The use of figures decreasing in size can help to show depth. Groups of people that are large in number will also impart the idea of a large space. Darken the figures as they become smaller, and silhouette those at the rear.

2 Facial expressions and direction, created by the foreground figures, can establish the mood of the sketch. To lead the eye into your picture, try leaving out the color on larger foreground figures, and focus their attention on something in the sketch.

**1**

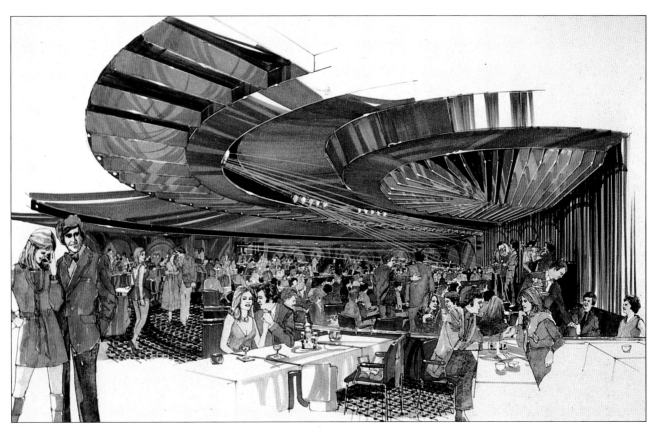

**2**

1

1   Use your figures to show what is happening in the space you are depicting. Retail spaces are for selling, so showing a purchase being made creates a positive image in the viewer's mind.

Lighting and form for people in your sketch is established by your lighting source and its direction. The light source is usually above the figure, so most highlights will be on the tops of the heads and shoulders. The lighting of the people in the sketch should blend in with the overall lighting plan, with shadows under the figures to establish their location and height.

2   Smiles are important, as is the direction of faces. If you create an interplay between figures, it can help to frame your sketch. Crowding is best avoided; a small space needs only enough figures to indicate to the viewer the use of the space. Develop a sense of stage direction; notice how all the figures in a play move and react to help the story.

3   Small spaces can seem larger by the careful overlap of figures. Notice how the foreground figure in this sketch is outside the space, yet entering it. The two people making a purchase are overlapping the sales counter, and the clerk placed behind the counter shows that ample space exists between the counter and the back wall.

**2**

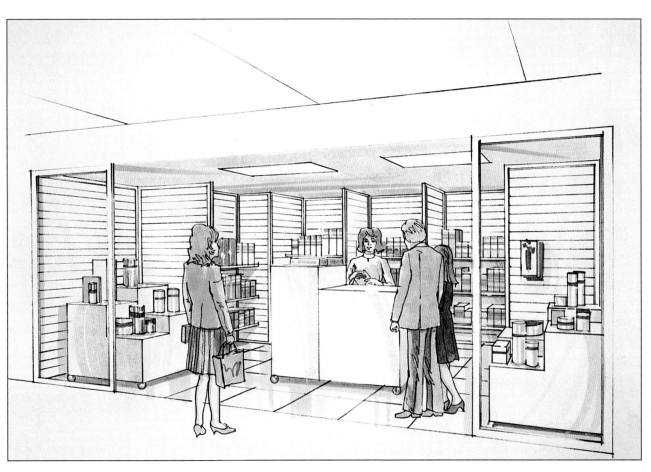

**3**

1  If you frequently use a grouping of figures, as in this typical hotel ballroom, you may be able to reuse your figures. This grouping was drawn once, for a ballroom rendering. The furniture is a typical stacking chair; the dress is eveningwear, which does not really change that much over the years.

The figures, tables, and chairs were isolated, copied onto a master, and recopied onto a new sheet of vellum, and then the room interior was drawn. This saves a lot of repetitive drawing, and the master can be reversed, enlarged, or reduced as the need arises. The use of different colors on the women's clothing helps to keep the drawing fresh.

2  Variations can be made by changing your foreground figures, or reversing your groupings by having the whole sketch copied onto mylar, then making a reverse electrostatic copy as a new master. Some of the people are the same in these two ballroom sketches, but new masters were created to provide variety.

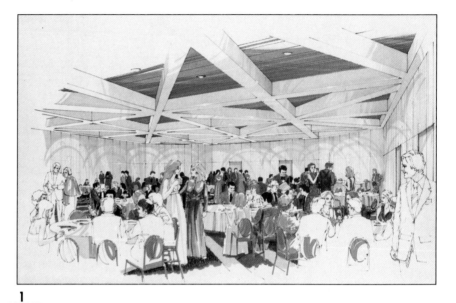

1

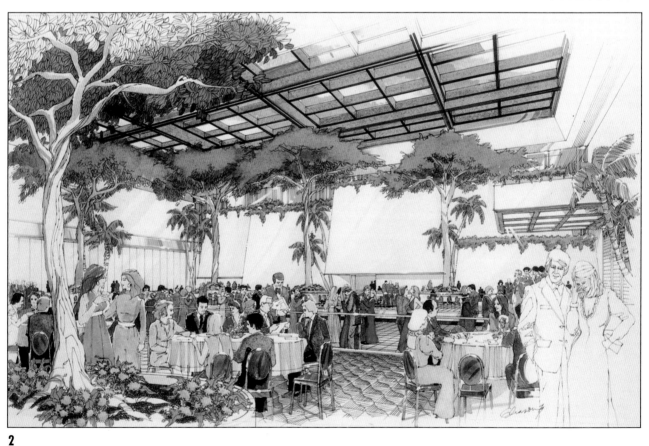

2

Here you see the same figures after they were copied onto a large sheet of vellum, with the interior drawn in later. Notice how many figures overlap and, in the shaded version, how the paper white was left at the outline to separate them. This also helps to create a dimensional quality in your figures, giving them a more "rounded" look.

The correct use of people in your sketch can really enhance the look of your work and add to the information you are presenting. The climate, clientele, and overall ambience can be described most effectively by how the people in your drawing look and dress. The function and center of interest often are totally controlled by how effectively you have placed the figures.

You have spent time and money to develop your drawing skills as they relate to your chosen field. Learning to draw people well will help to enhance the drawing ability you already have. Like anything worth doing, the time you spend to draw your sketches well will really show.

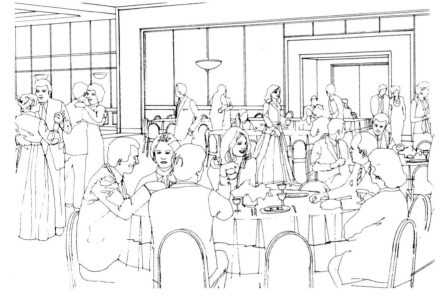

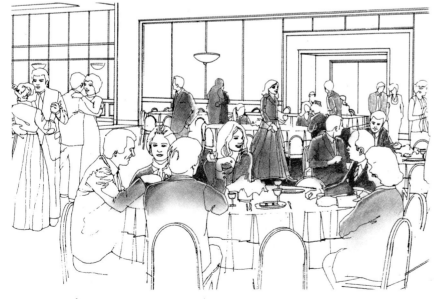

**NINTH STREET
COMMERCE CENTER**